IMAGES
*of America*

# WHALING ON
# LONG ISLAND

D1597181

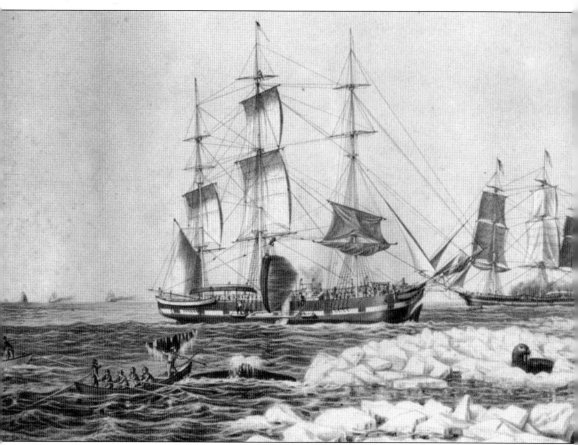

It all started here. Before the Long Island Expressway and sprawling suburbs were built, spouting by the island's coasts were the largest creatures ever to live on the planet, with too many of them to count. This book tells the story of Long Island's relationship with whales through 225 pictures, including the locations, communities, vessels, and tools that sustained the whaling industry. Long Island whalers followed these creatures to the far corners of the earth, even through the previously unexplored Bering Strait. In this image, a baleen jaw—the "plastic" of its time—is lifted onto the deck.

ON THE COVER: *In Pursuit of the Whale*. Technology and toil relied on each other in the whaling industry. Long Island scientist Robert Cushman Murphy photographed this whaleboat while aboard the *Daisy* in 1912–1913. Two iron harpoons point toward the sea.

IMAGES
*of America*

# WHALING ON
# LONG ISLAND

Nomi Dayan

ARCADIA
PUBLISHING

Published by Arcadia Publishing
Charleston, South Carolina

Printed in the United States of America

Library of Congress Control Number: 2015952888

For all general information, please contact Arcadia Publishing:
Telephone 843-853-2070
Fax 843-853-0044
E-mail sales@arcadiapublishing.com
For customer service and orders:
Toll-Free 1-888-313-2665

Visit us on the Internet at www.arcadiapublishing.com

*My gratitude to those who recorded this history before me, shared it with me now, and will teach about it in the future. My appreciation and affection to my parents, my husband, my sisters, and my children.*

# CONTENTS

# ACKNOWLEDGMENTS

Yankee whaling and photography for the most part missed each other, making research for this pictorial book like a treasure hunt. What surprised me was that the treasure included the people I met while conducting research. My gratitude to John Strong, who eagerly shared resources and advice; Mary Cummings of Southampton Historical Society; Sue Mullen of John Jermain Memorial Library; Michael Dyer and staff at New Bedford Whaling Museum; Louisa Watrous and staff of Mystic Seaport Museum; Rebecca Plock of Shelter Island Historical Society; Kathleen Cash of Port Jefferson Historical Society, with the help of Lawrence Mirsky; Daniel McCarthy of Southold Historical Society; Billie Carlebach, avid reader and clipper of the *New York Times*; Jeff Heatley of *Art & Architecture Quarterly/East End*; Amy Folk of Southold and Oysterponds Historical Societies; Richard Doctorow of Sag Harbor Whaling & Historical Museum; Wendy Polhemus-Annibell of Suffolk County Historical Society; Lucinda Hemmick of Southold Indian Museum; Melissa Andruski of Southold Free Library; Linda Pratt of Cohasset Historical Society; Robert Hughes and Zach Studenroth, town historians; Gina, Steve, and Andrea of East Hampton Public Library; Bridgehampton Historical Society; Richard Barons of East Hampton Historical Society; John Hanc and Daniel Goodrich; Quogue Historical Society; MaryLaura Lamont of William Floyd Estate Archives, Fire Island National Seashore; Kate Igoe of Smithsonian National Air and Space Museum; Joan Druett; Antonia Booth, Southhold town historian; and Margaret H. Gardiner of the Quogue Historical Society. One highlight was discovering the only known photograph of Capt. Jonas Winters in a family album with his descendant Morgan Peart of Arizona. For those individuals I mistakenly omitted, please know how grateful I am.

I am especially grateful for the hardworking and devoted staff team at the Whaling Museum. I am appreciative of my predecessor Paul DeOrsay for seeing potential in me before I knew what scrimshaw was. Thanks are due to helpful intern Caleb Weintraub-Weissman for his scanning assistance, and to Nina Dayan-Noy, Sara Dayan-Zoltan, and Leah Master-Huth for proofreading. My appreciation to the board of trustees for advocating for the publication of this book. Thank you to president Arthur Brings for being supportive of scholarly projects produced by the museum. Lastly, thank you to the circle supporters of the museum. It is you who have made the sharing of this history possible. Thank you!

All images used in this book come from the collection of the Whaling Museum & Education Center of Cold Spring Harbor, unless otherwise noted.

# INTRODUCTION

When we think of whales today, we are enchanted, enthralled, and amazed. We chase them on whale watching trips and cheer for a glimpse of their flukes; we watch documentaries about gray whale migrations and hold our breath in suspense when they swim past predatory orcas; we are touched when we see advertisements showing tender humpback mothers and calves and marvel at their affection; we read articles about whale intelligence and reach for dolphin-themed jewelry in stores; we choose screen savers of leaping humpbacks and post videos of whale encounters to our Facebook pages; we grieve when we read stories of beached whales and call others to action when we see whales in need.

These feelings are, for the most part, quite new. Our history with whales shows a much different relationship. Humans have chased these giant fish-monster-beasts without remorse for millennia, systematically wiping them out from one ocean to the next. This occurred mostly before a time when environmental health was understood or prioritized, before any concept of animal rights or cruelty to animals was felt, and before any idea that the ocean was not bottomless and would one day stop providing. Yet, the desire for wealth from whales pushed these creatures to the very verge of extinction. Why? Primarily because of their blubber. The products made from it for light fuel and machine lubrication are unlike any other substance on earth, along with their supple baleen used for fashion, and bones carved into utilitarian tools. Many people are shocked to learn how recently whaling occurred in significant numbers. Only decades ago, tens of thousands of whales were killed for pet food, transmission fluid, soap, and margarine—far more than any other time in history, forcing many species to the brink of extinction.

Long Island in particular has quite a distinctive relationship with whaling, with one notable first: The very first commercial whaling in the New World started right here on our shores. It all began on the east end of the island, particularly on the South Shore. The first true whalers here were Native Americans. While there is scant evidence for active, established whaling of large whales, it is believed communities primarily used beached or drift whales for food and possibly hunted smaller whales in dugout canoes. When Basque fishermen whaled off the Atlantic coast in the 1500s, it is possible the Indians gained whaling techniques from them. The first written account of Indians shore whaling on the East Coast dates to 1605. Images of these first whalers are unfortunately limited, but this does not necessarily suggest that whales were any less culturally important to the indigenous people.

Almost immediately after the Town of Southampton was established, whaling companies emerged. Settlers worked with Indians, and an agreement was made in 1667 with Tobacus, sachem of the Unkechaug Indians at Mastic, whereby the town was to pay the Indians five pounds in wampum for each whale captured. Colonial whalers relied heavily on the talent and strength of Indians, who were hired seasonally as contract workers. After whale populations close to shore declined, Indians continued their legacy by joining pelagic whaling expeditions.

Whaling put Long Island on the economic world map. After farming, whaling was Long Island's first industry. In fact, supplemental income from shore whaling (which took place during the winter season) coexisted beneficially with farming (which took place in the spring and summer). Whale oil was not only an important commodity, it was also used as a form of currency. There is a record of John Thomas of Setauket, who purchased a black slave named Samboe from Isack Rainer of Southampton for "19 barrels of good whale oyle." Ministers and schoolteachers were often paid in oil as well.

One can see the seeds of the American Revolution planted in some of the personalities of the island's whaling pioneers and the Colonial patriotism they showed in response to unfair laws established by several governors wishing to tap into their profits. Samuel Mulford was a particularly colorful local character who fought loudly against tyranny—perhaps for more than just the sake of whaling.

Whaling was one of Long Island's most important commercial industries, as it significantly shaped the local economic and social fabric through the years. It was very much a community enterprise, involving many merchants, trades, and people to supply the industry's numerous needs—blacksmith shops, sail lofts, cooperage shops, ropewalks, warehouses, chandleries, and shipyards—not to mention the many men from all over the island and beyond who found employment on voyages.

Whalers themselves had to be a particularly tough and courageous crew to endure the brutal conditions under which they worked and lived. One unique aspect of whaling was that it was America's first integrated industry. Although lower-ranked workers were exploited, everyone started out on an even footing and, if they worked hard, could rise through the ranks. African Americans, West Indians, Shinnecocks, Montauks, Portuguese, Polynesians, Colombians, New Zealanders, Cape Verdeans, and Kanakas were all regular crew members on whaling vessels and infused a great deal of cultural exchange in the trade. While they endured dangerous working conditions and abominable living conditions—including disease, undernourishment, and poverty—they also took advantage of an open economic opportunity that prized skill over skin color, something not present in other land-based American industries at the time.

Of course, there were those who built their fortunes in whaling. These individuals were not the lower-ranked workers who risked their lives with every whale hunt and endured "a most doggish life," as one whaler wrote in 1844. Rather, the money went into the pockets of the owners, agents, and captains. As time went on, the wages of whalers actually became worse and worse, with two-thirds of the ship's profits funneling straight to the owners. Glimpses of the homes of owners and captains attest to this distribution of wealth.

Long Island held three of the 72 whaling ports in the country, comprising 2,000 vessels. Long Island's ports were Sag Harbor (ranking approximately sixth nationally in number of vessels and number of voyages), Greenport (17th), and Cold Spring Harbor (27th). All three ports share remarkable stories of adventure and exploration, danger and shipwreck, bravery and pluck, and daring rescues.

In its heyday, whaling was one of the most lucrative businesses in the country; however, whaling was a victim of its own success. Whale oil allowed the Industrial Revolution to happen, which in turn opened up economic opportunities on land with better wages, less risk, and easier living. Getting a crew together became harder and harder in the face of abundant land-based, better-paying jobs. Other countries continued whaling and were successful, but the American industry was no longer profitable. In 1859, the discovery of petroleum in Titusville, Pennsylvania, spurred 2,000 barrels of petroleum in annual production; in 1862, that changed to three million barrels a year, produced far more cheaply than whale oil, which only filled 155,000 barrels that year. Other blows include the Gold Rush, which stole the dreams of both crewmen and captains; the over-exploitation of whale populations; changing fashions no longer requiring baleen; the Civil War; and finally, whaleships succumbing to the crushing ice in the Arctic. The American industry could not recover.

While whaling dwindled in the United States, it did not stop globally. It changed, primarily due to Long Island captain Thomas Roys's deadly invention: the harpoon rocket. This gave rise to whaling factory ships, which mercilessly hunted blue, fin, and humpback whales around the world. No whale could hide from underwater sonar and helicopter scouts.

Today, whale populations are recovering around the world, with some species bouncing back more readily than others. The blue whale, the largest creature to ever live on earth, is still endangered. At the time of this printing, there are just under 500 North Atlantic right whales left on the planet. The gray and humpback whales are both on the rebound.

Whalers themselves were a remarkably hardy group of people whose stories offer a unique societal parallel today. But most of all, we must have deep gratitude for the whale itself, which changed the course of human history in profound ways. It is now time for us to give back to our ocean-dwelling neighbors. For whale species to survive today, there is an important responsibility Long Islanders have: to apply our knowledge of whaling history to our current and future decisions affecting the marine environment. Every time we advocate for cleaner and quieter waters, we are saying "thank you" and, more importantly, "welcome back."

# One

# The Beginning

## Shore Whaling

Before Nantucket and New Bedford whaling, there was Long Island whaling. With Indian talent and European tools, whaling companies were born on our shores. Whales were chased, harpooned, and killed right off the Hamptons beaches, their oil boiled in tryworks in the sand.

In time, whales passing by the island's shores started to dwindle. Whalers resorted to going after whales with small sloops and towing their bodies back to shore. Soon, those whales ran out as well, necessitating longer voyages with larger ships to farther oceans. Ships with the ability to process the whale on the vessel itself, right in the open ocean, were eventually used. Whaling journeys of three to four years became common, and three Long Island ports were born to support those ships.

Sag Harbor stole the show as the major whaling port on the island, thriving during whaling's golden age. A wharf with tryworks was built at Sag Harbor in 1761, and the Long Wharf was constructed in 1770. When Capt. Daniel Havens led the Sag Harbor brig *America* to the South Atlantic in 1785 and returned with 300 barrels of oil, a century of Sag Harbor whaling began, bringing the village unprecedented wealth. Sag Harbor became a port of entry for New York in 1789, welcoming more vessels engaged in commerce than New York City, and became the state's first customs port in 1790.

Greenport and Cold Spring Harbor were the other two whaling ports on Long Island. While smaller in size, they offer a microcosmic view of the quintessential whaling town.

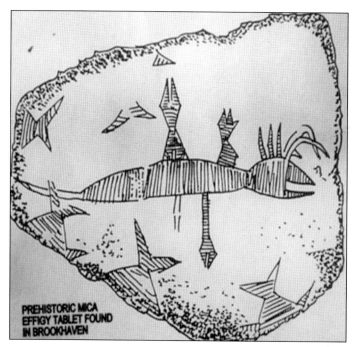

PREHISTORIC MICA EFFIGY TABLET FOUND IN BROOKHAVEN

It is believed the early Indians on Long Island held a deep fascination with and reverence for whales. At left is a sketch of a rock found by a farmer in Brookhaven in 1840. It has been suggested by scholar John Strong that the drawing may represent a sea spirit—possibly a whale—in a pod of fish. Below is a whalebone paddle found on Shelter Island, crafted by indigenous people. (Left, courtesy John Strong and David Martine, New York State Museum; below, courtesy Southold Indian Museum.)

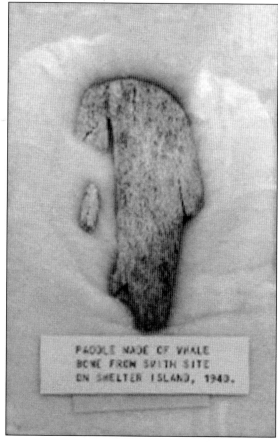

PADDLE MADE OF WHALE BONE FROM SMITH SITE ON SHELTER ISLAND, 1943.

This 1595 engraving by Theodor De Bry shows the "Supposed Indian Method to Catching Whales." There is little documentation of active, systematic whale hunts by Long Island Indians before white settlers arrived, but beached or drift whales were taken advantage of. Smaller whales were perhaps corralled to the beach. (Courtesy New York Public Library.)

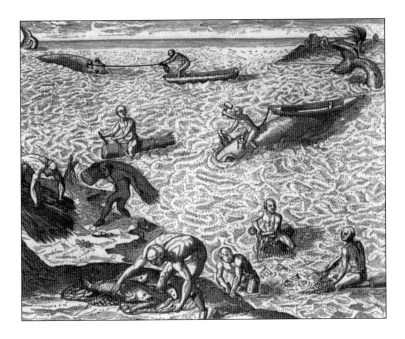

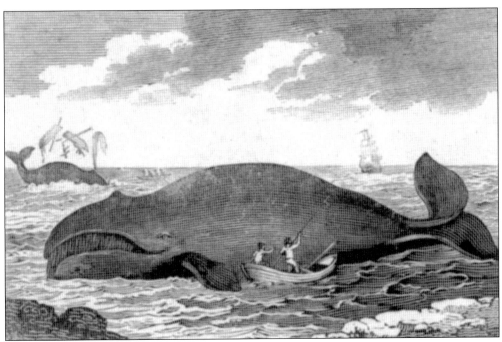

Shore whaling was directly dependent on the Northern Atlantic right whale, which migrated past the island's coast every winter. Several factors made this species the "right" whale to hunt: half its weight was fat, its baleen was long, it was a slow swimmer, it was a surface feeder in relatively shallow waters, and it remained buoyant after death. In this engraving, an unfortunate boat faces a whale's fury in the distance. (Courtesy New York Public Library.)

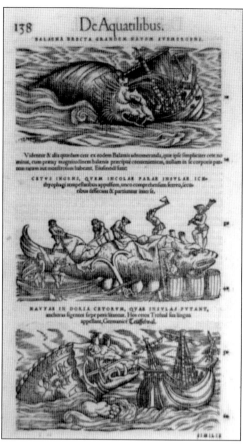

This illustration created around 1551–1558 is part of the first modern zoological work by Conrad Gesner of Zurich, which attempted to describe all animals known. It is useful for showing the European understanding of whales right before Long Island became a whaling scene. The image depicts a monster whale sinking a ship, men stripping blubber from a whale, and sailors on the back of a whale they mistook for an island. (Courtesy Library of Congress.)

At the time of Long Island's colonization, the Dutch were world leaders in whaling. Much of people's understanding of whaling at the time came from Dutch observations, hunting tools, and equipment, which Long Island whalers would build from. This Dutch whaler is in the Nova Zembla fishery in 1684.

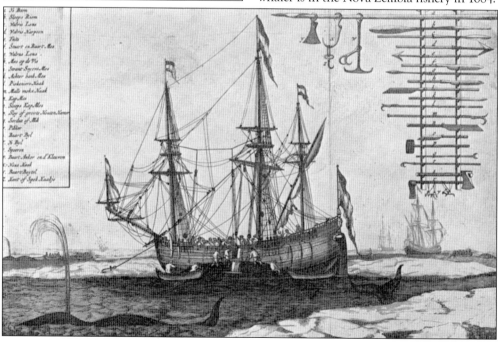

After Long Island was colonized in 1625, Dutch patroon Samuel Godyn sent Capt. David Peterson De Vries (pictured) to explore whaling in New Amsterdam in 1630. He returned nearly empty-handed. He went on two more voyages looking for whales. (Courtesy University of Cambridge Library.)

The Dutch West India Company wrote to Dutch colonial governor Peter Stuyvesant to instruct him to open up a whale fishery on Long Island. He sent a delegation in 1655 to look into the possibility and was shocked to find bustling shore whaling activity, with many of the island's whalers shipping their oil to Boston rather than a Dutch port to avoid taxes. (Courtesy New York Public Library.)

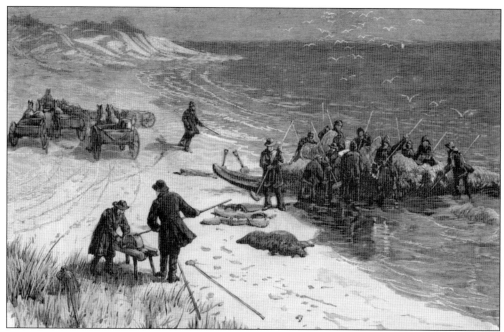

America's first commercial whalers were Southampton beachcombers pursuing seasonal cash on a small scale. In 1644, Southampton was divided into four districts in which people could salvage whale carcasses. Indians were permitted to take the tail and fins. By 1687, there were 14 whaling companies in Southampton. That year's whale oil total was 2,148 barrels.

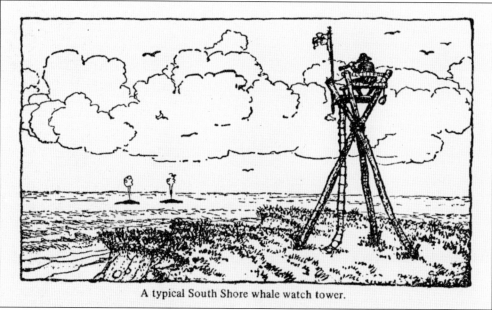

A typical South Shore whale watch tower.

Southold, too, was an early contender in the industry. After the town was founded in 1640, a whaling company was established for catching "porpoises, grampuses and drumfish." Early whalers built lookout towers right on the beach, looking for the telltale spouts of passing whales. One must admire the courage of whalers who paddled into the frigid winter ocean to pursue these enormous creatures.

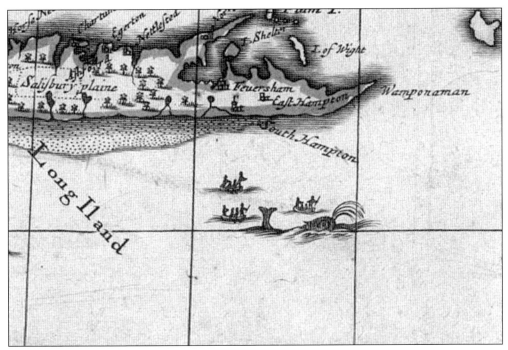

What is interesting about this map of Long Island from around 1690 is the iconography detail, which depicts the earliest known whaling scene in the New World. The men in rowboats are likely Indians employed by settlers. (Courtesy New York Public Library.)

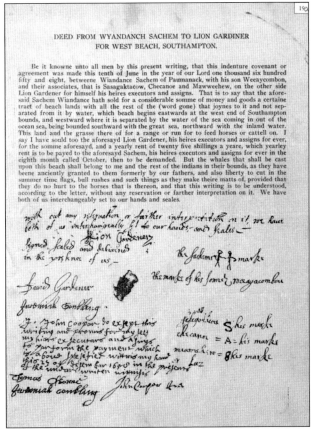

DEED FROM WYANDANCH SACHEM TO LION GARDINER
FOR WEST BEACH, SOUTHAMPTON.

Be it knowne unto all men by this present writing, that this indenture covenant or agreement was made this tenth of June in the year of our Lord one thousand six hundred fifty and eight, betweene Wiandance Sachem of Paumanack, with his son Weeaycombon, and their associates, that is Sasagaktacow, Checanoe and Mawwechew, on the other side Lion Gardener for himself his heires executors and assigns. That is to say that the aforesaid Sachem Wiandance hath sold for a considerable somme of money and goods a certaine tract of beach lands with all the rest of the (word gone) that joynes to it and not separated from it by water, which beach begins eastwards at the west end of Southampton bounds, and westward where it is separated by the water of the sea coming in out of the ocean sea, being bounded southward with the great sea, northward with the inland water. This land and the grasse there of for a range or run for to feed horses or cattell on. I say I have sould too the aforesaid Lion Gardener, his heires executors and assigns for ever, for the somme aforesayd, and a yearly rent of twenty five shillings a yeare, which yearly rent is to be payed to the aforesayd Sachem, his heires executors and assigns for ever in the eighth month called October, then to be demanded. But the whales that shall be cast upon this beach shall belong to me and the rest of the indians in their bounds, as they have beene anciently granted to them formerly by our fathers, and also liberty to cut in the summer time flags, bull rushes and such things as they make theire matts of, provided that they do no hurt to the horses that is thereon, and that this writing is to be understood, according to the letter, without any reservation or farther interpretation on it. We have both of us interchangeably set to our hands and seales.

This 1658 deed documents the sale of West Beach in Southampton from Sachem Wyandanch to Lion Gardner (a whaler). The right of beached whale harvesting remains with the Shinnecocks. (Courtesy Long Island Collection, East Hampton Public Library.)

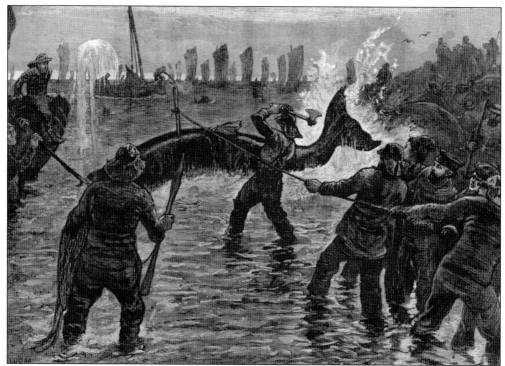

Dutchman James Loper set up the first whaling station in East Hampton with his stepfather around 1668, employing many Indians. He was so successful that the town of Nantucket, which wished to get in on the game, offered him parcels of land in 1672 if he would teach them how to whale and "carry on a designe of whale fishing" similar to that pictured here. He chose to remain on the island.

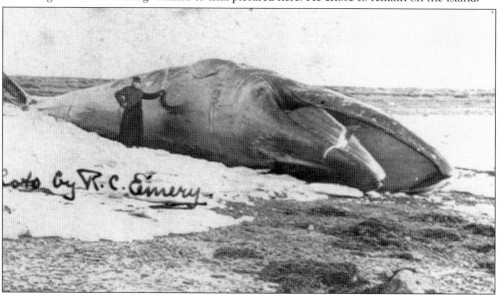

This early 1900s photograph shows how whales were locally abundant in Colonial times. At one point, they were reportedly seen daily in New York Harbor, and strandings were common. In 1669, Samuel Maverick wrote that 13 whales were caught on the South Shore that winter and 20 more that spring.

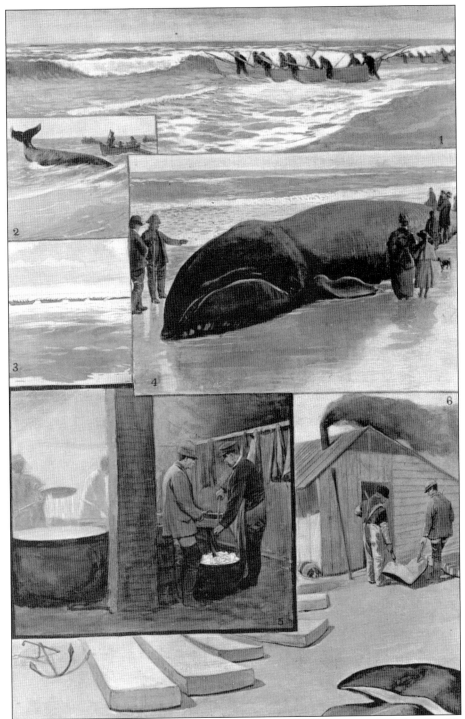

These drawings show the details of how shore whaling was conducted, from the "Thar She Blows!" of sighting a whale, harpooning the whale, towing the carcass to shore, and processing the blubber in the tryhouse. One can see why in the early days of whaling on the island, school let out from December through April so there would be "all hands on deck" for the winter whaling season.

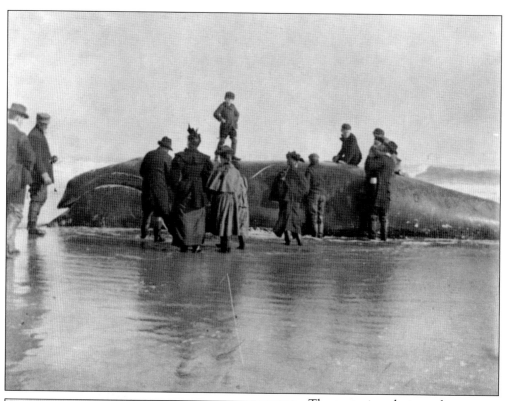

The next nine photographs were taken in the early 1900s on the island and represent what Colonial shore whaling would have looked like. (Courtesy East Hampton Historical Society.)

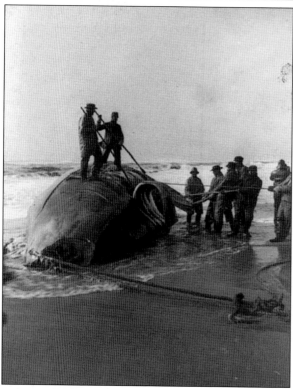

In this 1908 photograph, two men stand atop a beached whale and use long-handle spades to remove blubber. Men on the beach use ropes to help peel away skin. (Courtesy Underwood & Underwood, Library of Congress.)

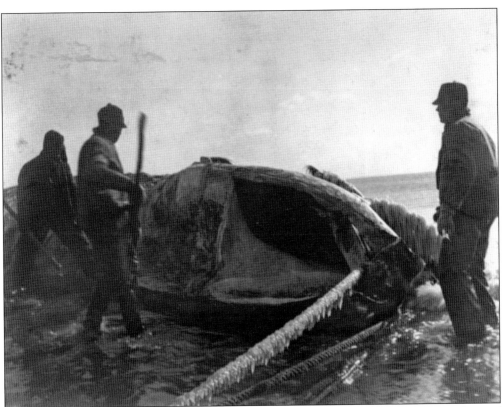

The whale's mouth is pictured here. Mysticete ("mustached") whales have keratinous plates of baleen instead of teeth, often referred to as whalebone. Similar to human fingernails, baleen enables whales to filter large quantities of prey from seawater. Some baleen whales are gulp feeders (such as humpback whales), some are skim feeders (right whales), and some are bottom feeders (gray whales). Because baleen is strong yet flexible, it was used in the creation of many household and luxury items. (Courtesy East Hampton Historical Society.)

This view is of the underside of a whale, with a young man curiously examining the baleen bristles. Throat pleats, characteristic of the rorqual family of whales, expand to accommodate large amounts of water, which is strained. (Courtesy East Hampton Historical Society.)

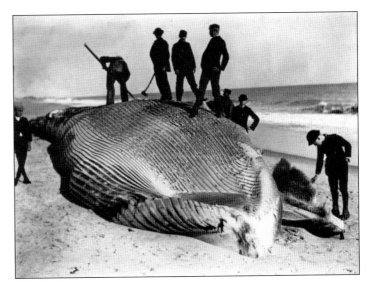

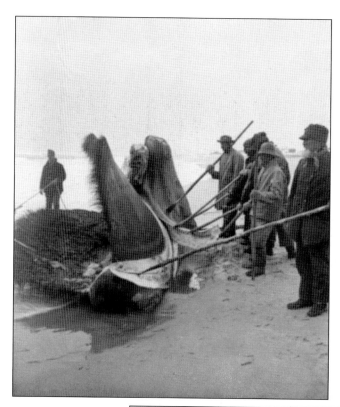

The whale's jaws are separated. Fringe plates of baleen are visible on the whale's upper jaws. Before plastic and steel, baleen was widely used in women's fashion. In the 20th century, what was once an irreplaceable material was discarded. (Courtesy East Hampton Historical Society.)

This photograph is dated June 15, 1907, in East Hampton. The caption reads, "Picture shows body of whale captured here last winter." There is a marked contrast in the triumphant stance of the man on top of the whale compared to our nation's feelings towards these creatures today. (Courtesy East Hampton Historical Society.)

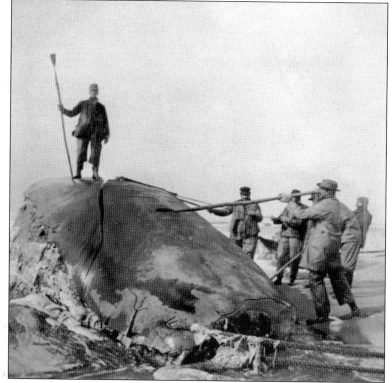

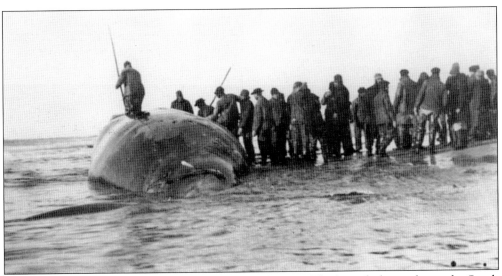

This photograph shows a view of the whale from the rear. The last whale caught on the South Shore was in Amagansett in 1918. (Courtesy East Hampton Historical Society.)

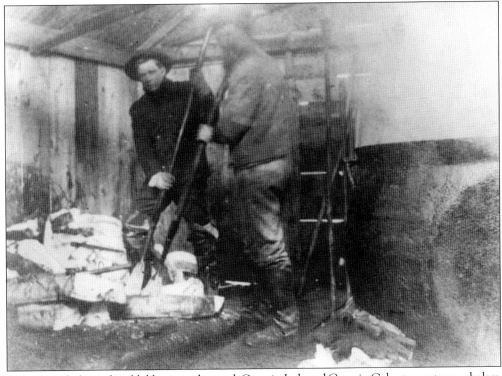

A sharp spade for peeling blubber was a key tool. Captain Josh and Captain Gabe, two veteran whalers, polish spades on the beach in Amagansett. (Courtesy East Hampton Historical Society.)

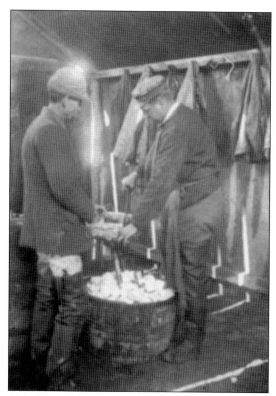

After the whale carcass was stripped of blubber, the blubber was cooked in trypots, which resemble huge cauldrons, to render the oil. Towns soon passed ordinances and public orders to try to control the smoky stench of whale blubber cooking and the filth associated with it. (Below, courtesy East Hampton Historical Society.)

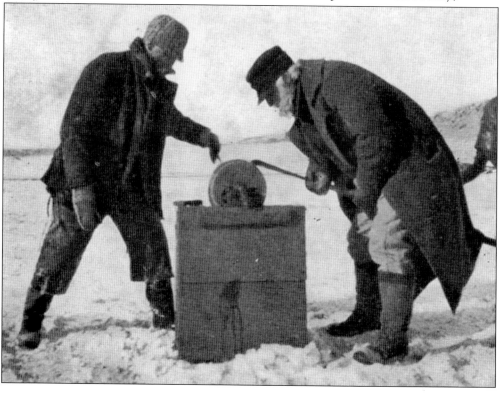

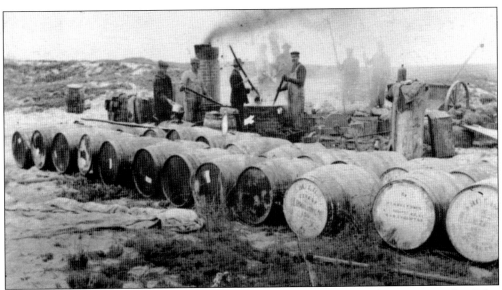

Cooled whale oil was sold by the barrel. This 20th century photograph represents what John Ogden's whaling business would have looked like (1609–1682). He started the first commercial whaling enterprise in the country by securing an exclusive license to kill whales, as reported in the 1650 Southampton town records. He sold his products in New Amsterdam and likely New England. An early entrepreneur on Long Island, Ogden continued to be active in the whaling industry when he moved to New Jersey. (Courtesy East Hampton Historical Society.)

Know all men by these presents That I Arthur Indian Doe binde myself unto John Cooper of Southampton to Doe the said Cooper good and faithfull service in labout Whaling or cutting out of whale, And not to absent myself at any time from the said Coopers business as above said, when season and opertunity of wether p mits, I say I binde myself for y term of tenn yeares, that is to say for four trading cloth coats by the yeare for my wages, and not to exad untill the full terme bee expired, to the true p formance hereof I set to my hand and seale March the 4. 16 70/71 Arthur his marke

The Shinnecock, Montaukett, and Unkechaug played a fundamental role in the development of shore whaling, and competition for skilled Indians could be fierce between rival owners. This is a 10-year contract for whaling between Artor and John Cooper of Southampton, drafted in 1670. (Courtesy Town of Southampton.)

Wosquasuks oldest
son sauing ingaged to
go to so i so son the II of iul
1684 wosoued i pound of
poudor
and a gill rum
and a quart of sidor
To i pound of poudor
To 3 pound of slot
To i cot — — 01-8
To 2 gorns of poudor
To 4 locks of slot
To i pound of tobaco
To i pound of poudor
To i gil of slot
To ½ a gil of slot
To ½ a gil of slot
To i pound of tobaco
To i pound and calf quarter
of poudor
To 2 pound _____ of slo
To i pound of poudor
To 2 pound of slot and calf
To i pint of rum
To i pound of poudor

Indians asked primarily for gills of gunpowder and shot, as well as corn, tobacco, cloth, shoes, coats, knives, and rum—the latter planting cycles of alcohol abuse that would plague their communities. One 1670 contract paid Indian whalers three coats, shoes, shot, and several other items for three years of work. After 1676, Indians demanded a share of oil and bone profits as well. Shown here is a detail from Richard Floyd Jr.'s ledger book, with goods paid to "Wasquasuk's oldest son" in 1684. Floyd was a merchant who lived from 1665 to 1738 on the Pattersquash farm in Mastic. (Courtesy Huntington Library/William Floyd Estate Archives.)

Unfortunately, Indian whalers were tied into seasonal cycles of exploitation and debt. One Indian whaler, Artor, got so far in debt that he had to indenture himself to Joseph Fordham. This indenture contract is dated December 10, 1679. (Courtesy Town of Southampton.)

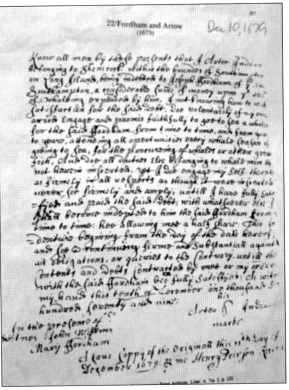

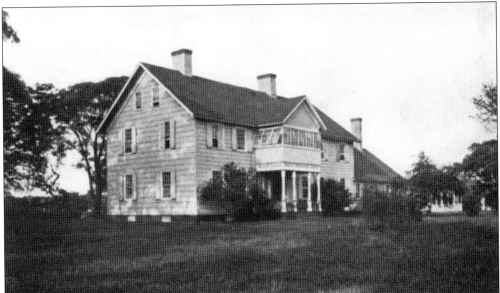

Col. William Smith (nicknamed Tangier because he had been an English governor of Tangier, Morocco) established the huge estate of St. George Manor in 1696 and employed Unkechaug whaling crews. He kept a ledger, the "Pigskin Book," from 1696 to 1721, detailing shore whaling records. It included the many debts local Indians accumulated as they stocked up on European goods. His wife, Martha, continued the business after his death, averaging 20 whales a season. Shown is the Manor House in Mastic. (Courtesy J.B. Lippincott Company.)

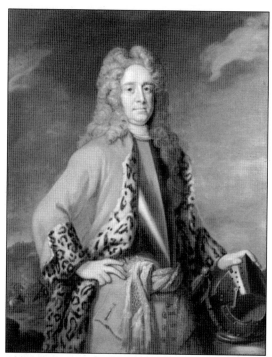

Starting in the 1670s, multiple New York governors, such as Gov. Robert Hunter (1664–1734; 1720 portrait), levied special taxes on whale oil for the benefit of the crown, demanding a percentage of profits of the "royal fish," up to half of the oil and bone, a purchased license, and exportation through the port of New York. Many Long Island whalers flouted these laws with contempt.

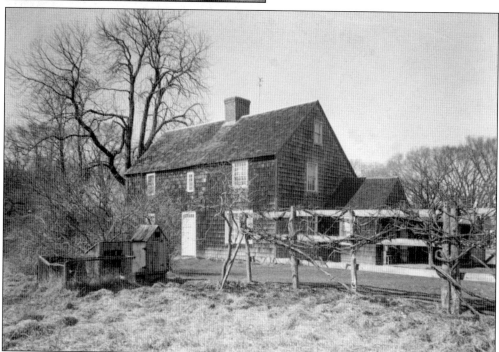

Samuel Mulford (1644–1725) of East Hampton was a local champion of Colonial whaling rights, although Governor Hunter described him as a "crazied man." With a whaling company of 24 men, he built the first wharf in the Hamptons. Strong-willed, he went to London in 1704 to successfully protest the whale oil tax (with fishhooks in his pockets to deter thieves). His farmhouse (pictured) is one of the oldest in Suffolk County. (Courtesy National Park Service.)

Maj. Thomas Jones was an astonishing opportunist. After he left Ireland in 1692 as an exiled soldier, he used his charm and entrepreneurial intelligence to rise in society. In 1705, he secured a license to establish a whaling station near present-day Jones Beach, creating a monopoly in the area. Competitors near "Mereck Beach" were soon out of business or paying usage fees to him. Jones died in 1713, survived by seven children. Two of his great-grandsons began the Cold Spring Whaling Company. (Courtesy John Hanc and Daniel Goodrich.)

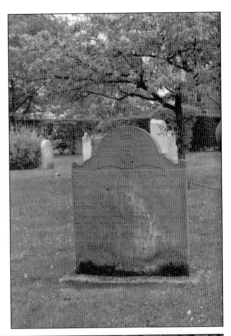

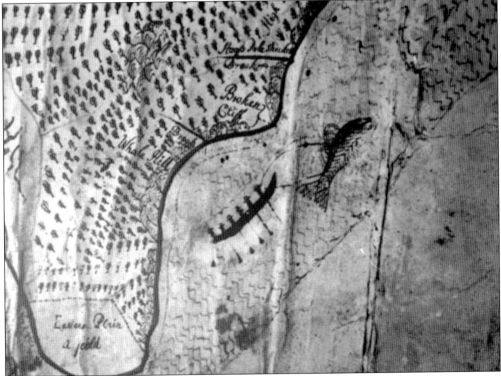

Various acts passed by the British Parliament to encourage the whaling industry in the empire helped the industry prosper in the first half of the 18th century. This included a 1708 act forbidding the detainment of any employed Indians from whale-fishing. Shown here is a detail from a 1722 map of Gardiner's Island. The whale is depicted as a fish, since whaling at the time was essentially seen as a form of profitable sportfishing. (Courtesy East Hampton Historical Society.)

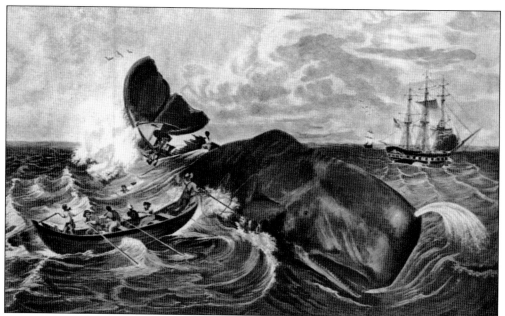

The first sperm whale was killed off the coast of Nantucket in 1712, forever changing the face of whaling—especially at a time when shore whales were becoming scarce. These deep-diving, feisty whales (shown harpooned above and beached below in a 1598 engraving) could not be caught close to shore, necessitating longer voyages with fully rigged ships. Sperm whales provided not only high-quality oil but also spermaceti wax from their heads. When this wax was cooled, pressurized, and treated with an alkali, it formed the highest quality of fuel known at the time. Odorless and bright, spermaceti candles were prized as a luxury item. Future president John Adams tried to convince the British to use sperm candles for streetlamps because it was "the clearest and most beautiful flame of any substance that is known in nature."

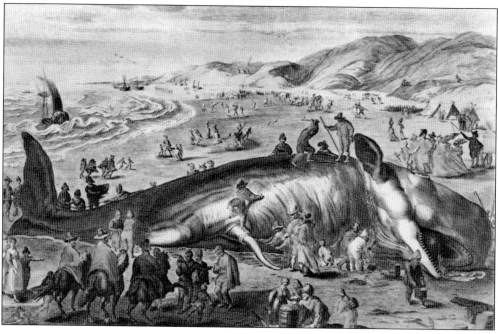

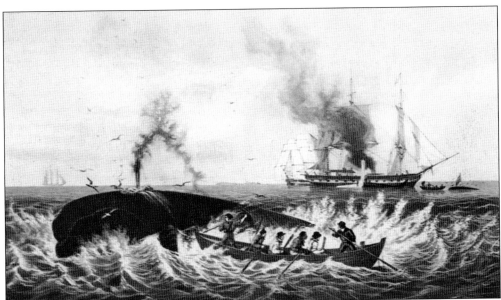

There could be great variability in catches from year to year. In 1707, Long Island whalers caught 111 right whales, yielding 4,000 barrels of oil and setting a record. Yet the following year, only 600 barrels were produced. The price of whale oil could fluctuate as well. Here, a cloud of black smoke, which characterized whalers, is seen coming from the ship behind the right whale. Whaleships were recognized by their black smoke and stench for miles by day and their illuminated sails from the glowing tryworks at night.

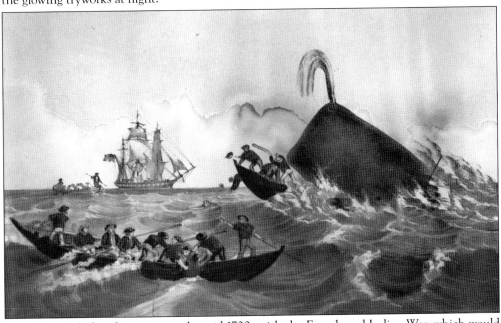

Long Island whaling hit a snag in the mid-1700s with the French and Indian War, which would continue to happen in future wars. Instead of hunting in the Davis Straits near Canada, slow-moving and poorly armed whalers tried to avoid attack from privateers and pirates by turning south toward Brazil, grounds that Long Island whaleships would continue to haunt in the future. Shown here is a "flurry"—the violent and dangerous rolling of an expiring sperm whale.

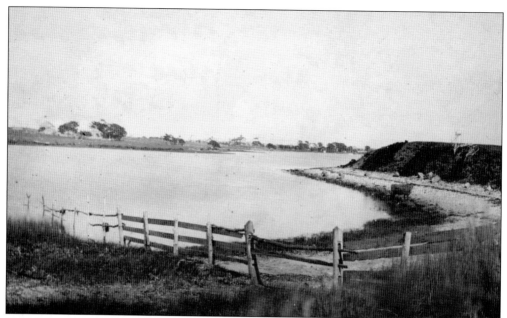

Sag Harbor was first mentioned in town records in 1707, with permanent settlement occurring there in 1730. Because whaling fleets were now expanding with grander ships to go deep-sea whaling, larger and deeper ports were needed. Southampton's shallow port was bypassed for Sag Harbor as the century progressed. Pictured above is a bucolic view of the cliffs, with several houses in the distance; below is a view of a more industrialized village as seen from the dock in 1879, after the whaling surge had passed. (Both, courtesy Brooklyn Collection, Brooklyn Museum/ Brooklyn Public Library.)

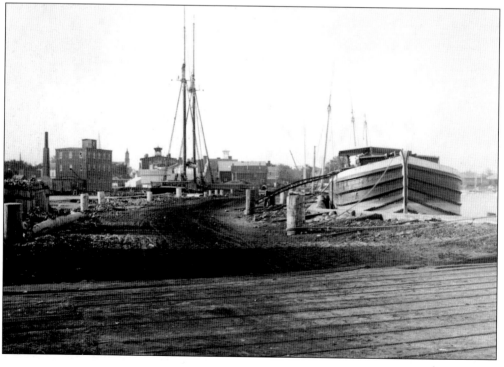

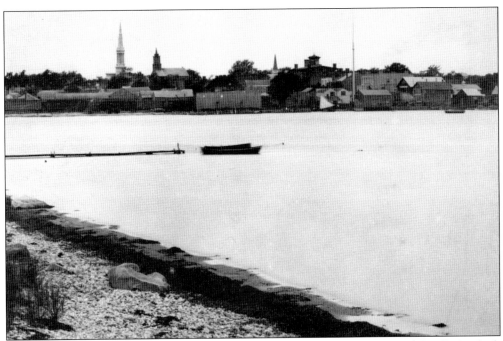

The first three whalers to leave Sag Harbor in 1760 were the *Dolphin*, *Success*, and *Goodluck*, which whaled along coasts as far north as Disko Island, Greenland, and returned with the blubber to boil on shore. Because ships had to venture farther to find whales, blubber often spoiled before reaching the shore. Therefore, tryworks were installed on the whaleships themselves. The first of these ships was the *Hope*, which sailed out in 1784 by the Gardiners. This is an 1878 view of Sag Harbor from the east shore of North Haven, called Hog Neck at the time. (Courtesy Brooklyn Collection, Brooklyn Museum/Brooklyn Public Library.)

Long Island whalers supported the American Revolution, although the war brought the industry to a standstill. Idle whaleboats played a surprising role in the war, with guerilla-like raids across the sound. In one example, Col. Return Jonathan Meigs led 230 men in whaleboats to sack Sag Harbor in 1777. One of the war's last battles took place on December 7, 1782, with vicious hand-to-hand combat between patriot and loyalist whaleboats on the sound. (Courtesy New York Public Library.)

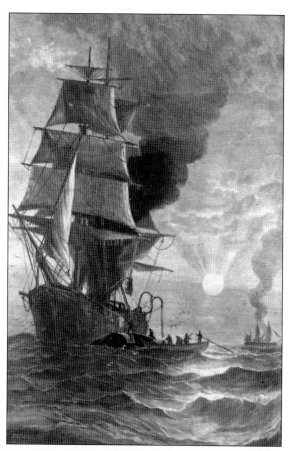

Ships could now remain at sea on longer voyages; by the early 1800s, voyages could last three years. In 1785, the ship *Lucy*, owned by Benjamin Huntting and Stephen Howell of Sag Harbor, returned from Brazil with 360 barrels of oil. Her journey would have looked like the image shown.

Bringing in a sperm whale could be a dangerous experience. Several whaleboats would stay close, so in case one boat capsized in a whale's tossing fury (as illustrated here), men would have a chance to escape. This engraving was published in Harper's Weekly in 1866 and captures the drama of the hunt.

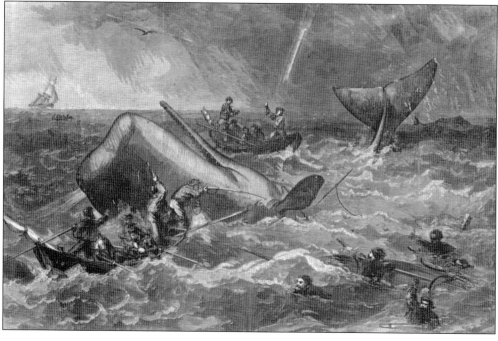

# *Two*

# THE GOLDEN AGE

## A DEAD WHALE OR A STOVE BOAT

After the War of 1812, American whaling was free of international conflict. Thereafter, it surged into its golden age, which extended through the 1850s. Whaling became the fifth largest industry in the country, and America became a world leader in whale oil production. In 1847, of the 900 whaleships worldwide, about 85 percent were American vessels. Whaleships could barely sail out fast enough to meet the growing demand for lamp oil and baleen for women's fashion, perfume, and lubrication, which made the Industrial Revolution possible.

The main ports of Sag Harbor, Greenport, and Cold Spring Harbor managed over 143 whaling vessels, which collectively made more than 1,000 voyages (nearly 600 of which sailed from Sag Harbor). Sag Harbor even earned a mention in Melville's *Moby Dick*. At Sag Harbor's height in 1846–1847, sixty-three vessels began their journeys from the harbor. Of those, 32 arrived that year, bringing a total of 4,000 barrels of sperm whale oil, 64,000 barrels of right whale oil, and 600,000 barrels of baleen (whalebone). Whaling towns pooled resources, including crewmembers. In one example, most whalers on the Sag Harbor ship *Thomas Dickason* were from the Hamptons.

Now that whaleships could process blubber at sea, they adventured to every ocean and every continent. As whalers had to travel increasingly farther to make a profit, voyages became longer—typically two to four years. Thousands of men, both Long Islanders and those from distant locales, joined local whaling crews and charged after the leviathans in mortal combat with the cry, "a dead whale or a stove boat!"

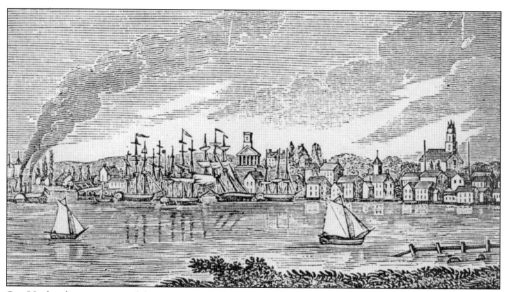

Sag Harbor became one of the greatest whaling ports of the country—and the world. This woodcut shows a northern view of the harbor around 1841, which was when whaling reached new heights on the island. That year, 30 vessels brought 6,727 barrels of sperm oil, 58,827 barrels of whale oil, and 482,110 pounds of whalebone. Whale products brought to Sag Harbor that year totaled $660,000. Visible in the center of this image is the lower tower of the prior Presbyterian church, which was built in 1817 and later sold. Old Whalers' Church was not yet built, but its steeple would become the most prominent feature of the village. (Courtesy John Jermain Memorial Library.)

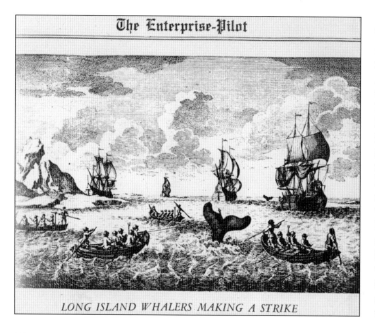

LONG ISLAND WHALERS MAKING A STRIKE

This newspaper illustration reflects the industry's exciting growth. A new whaling age for the island was ushered in by the *Argonaut*, the first Long Island whaleship to extend past Brazil and round Cape Horn to whale in the South Pacific. The *Argonaut* returned after a 20-month voyage in 1819 with 1,700 barrels of sperm whale oil, opening a new door for Long Islanders. The vessel was commanded by Capt. Eliphalet Halsey, and a long line of Halsey whaling masters followed.

Financing a whaleship was expensive. The 262-ton *Union* was the first Sag Harbor ship financed by shareholders. The *Union* overall had a successful career, with 14 voyages totaling $350,000. One noteworthy shareholder was author James Fenimore Cooper (1789–1851), whose wife had family in Shelter Island. The three voyages he sponsored yielded poor returns, which was perhaps fortunate, as this failure turned him back toward writing novels, including *The Last of the Mohicans.* Cooper is pictured here one year before his death. (Courtesy Brady National Photographic Art Gallery.)

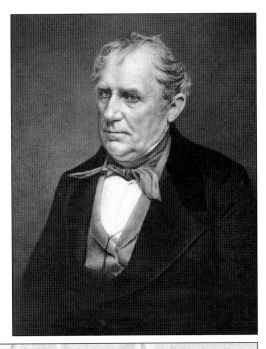

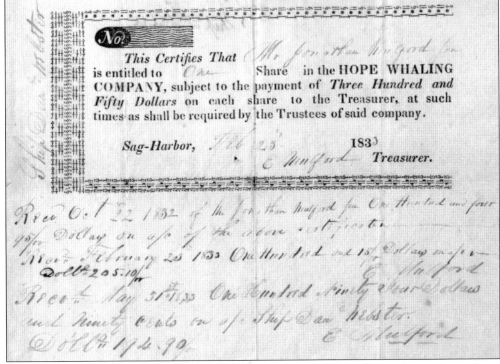

Many Long Island families were shareholders in local whaling voyages. Shown is a stock certificate of the Hope Whaling Company of Sag Harbor for one share at $350 to Jonathan Mulford on February 23, 1833. It was signed by treasurer and owner E. Mulford for the specific voyage of the *Daniel Webster,* which sailed to the South Atlantic from 1833 to 1837. (Courtesy Long Island Collection, East Hampton Public Library.)

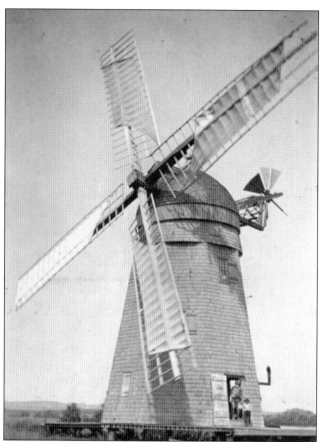

Constructed on Sleight's Hill in Sag Harbor in 1820 for retired whaling captain and shipbuilder Lester Beebee, this windmill was at one point the tallest structure in Sag Harbor. When a homeward-bound whaleship was sighted, a flag was hoisted, starting the local expression "flag on the mill, ship in the bay." (Courtesy Bridgehampton Historical Society.)

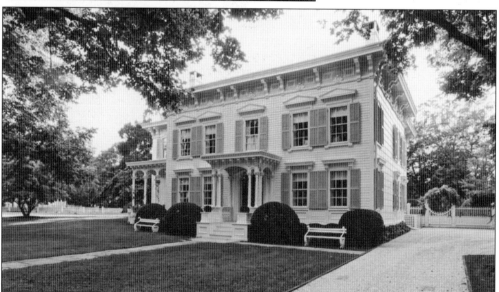

This handsome 1834 house was built for Hannibal French, a wealthy investor of the largest fleet of whaling ships in Sag Harbor at the time. The house is an excellent example of Italianate Double-bracket style. (Courtesy *Art & Architecture Quarterly/East End.*)

Minard Lafever, the architect behind Old Whalers' Church in Sag Harbor, designed this grand home for Benjamin Huntting II (right), an entrepreneur who made a fortune in whaling. Built at the height of Sag Harbor's prosperity, the 1845 building (below) is perhaps the finest example of Greek Revival architecture on Long Island. The structure became the Sag Harbor Whaling Museum in 1936. (Right, courtesy Collection of Sag Harbor Whaling & Historical Museum; below, author's collection.)

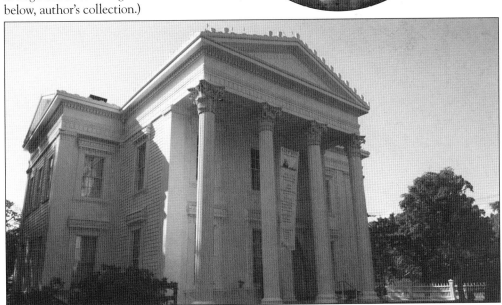

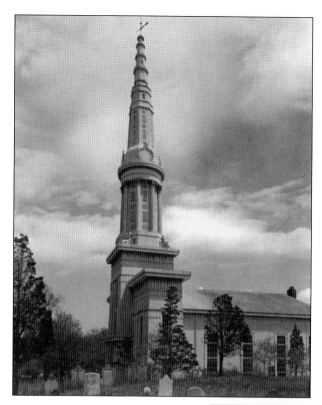

Known as Old Whalers' Church, the grandeur of this Presbyterian church reflects Sag Harbor's prosperity as a whaling town. It was built in 1844 in Egyptian Revival style, complete with a blubber-spade motif on the roofline. A National Historic Landmark, its 185-foot steeple, which could be seen by returning mariners, was destroyed in the 1938 New England hurricane and was not replaced. (Courtesy New York Public Library.)

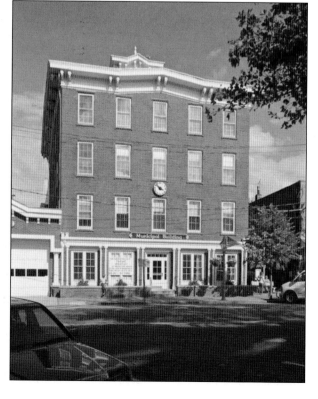

This imposing hotel, constructed in 1846 at the height of the golden age of whaling and Sag Harbor's growth, reflects the economic confidence of its time. The year before, Sag Harbor suffered a disastrous fire and lost two whaling vessels, wharves, shipyards, warehouses, and many businesses. (Courtesy *Art & Architecture Quarterly/East End*.)

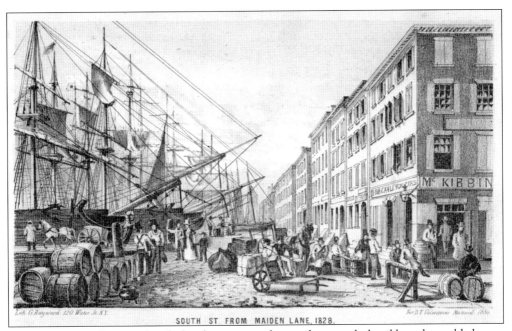

SOUTH ST. FROM MAIDEN LANE, 1828.

Whale oil prices fluctuated with the changing market, and many whale oil barrels would change hands in New York City. The year 1847 was known as the "million-dollar year" in Sag Harbor, when 32 ships poured unprecedented wealth into the village. This photograph is of South Street Seaport from Maiden Lane in New York City.

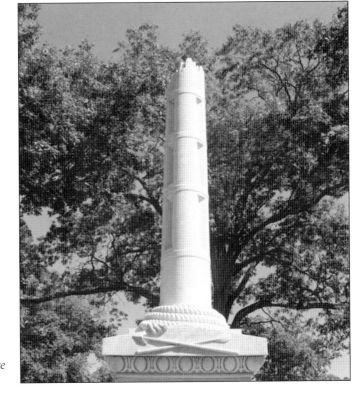

Alongside fortunes came tragedies. Sag Harbor's Oakland Cemetery houses the 1845 *Broken Mast* monument, sculpted by Robert E. Launitz in memory of the "sons of Southampton who periled their lives in a daring profession and perished in actual encounter with the monsters of the deep." (Courtesy *Art & Architecture Quarterly/East End*.)

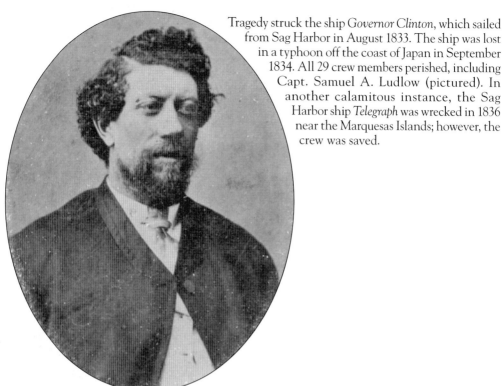

Tragedy struck the ship *Governor Clinton*, which sailed from Sag Harbor in August 1833. The ship was lost in a typhoon off the coast of Japan in September 1834. All 29 crew members perished, including Capt. Samuel A. Ludlow (pictured). In another calamitous instance, the Sag Harbor ship *Telegraph* was wrecked in 1836 near the Marquesas Islands; however, the crew was saved.

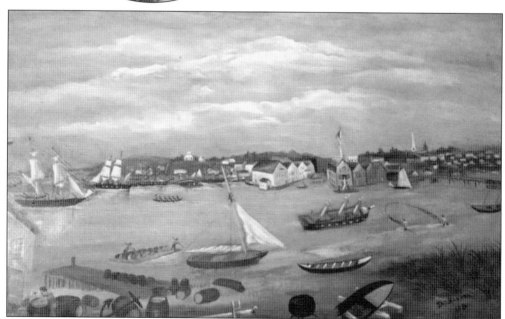

This seemingly simple painting of Sag Harbor from 1860 depicts many wonderful details. Starting at the left in the foreground are John Budd's dock, warehouse, and oil cellar; a cooper at work; men rafting barrels of oil from a ship; tryworks on the shore; and an old whaleship, the *Hudson*, stranded. In the background, four whalers are at Long Wharf; One is "hove down" (careening). (Courtesy Collection of Sag Harbor Whaling & Historical Museum.)

The original Cedar Island Lighthouse was constructed in East Hampton in 1839 at the mouth of Northwest Harbor, guiding Sag Harbor whaleships into the ocean and welcoming them on their return. The lighthouse was replaced by this structure in 1868. Sperm whale oil in particular was sought after for lighthouses around the country for its clear, bright burning properties.

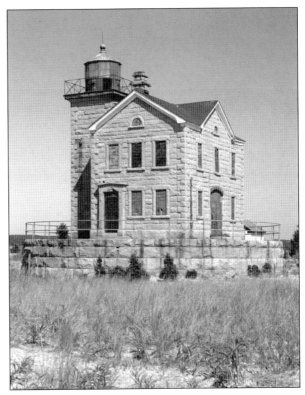

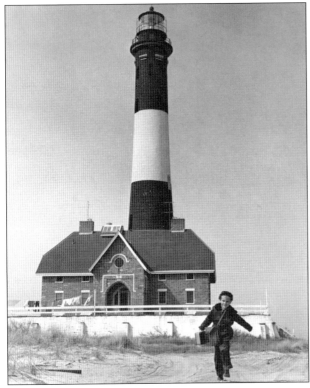

The Fire Island Lighthouse used various fuels during its existence, but the earliest was whale oil. In this 1952 photograph, the lightkeeper's son, five-year-old Richard Mahler, is on his way to school, four miles away. (Courtesy *New York World-Telegram and Sun* Newspaper Photograph Collection, Library of Congress.)

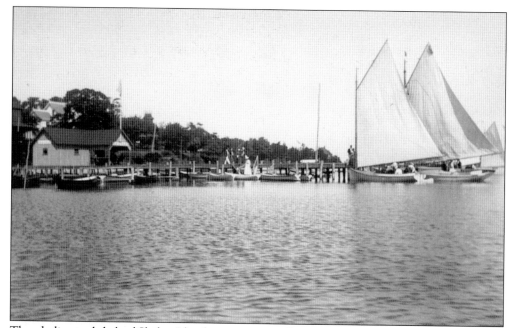

The whaling trade helped Shelter Island prosper, especially when Sag Harbor became an official port of entry for New York in 1789. Its success and international trade was felt by Shelter Island, which produced captains, shipbuilders, and other workers who prepared Sag Harbor and Greenport vessels for their journeys. This photograph is dated 1889. (Courtesy Shelter Island Historical Society.)

This home on Shelter Island was originally built by Capt. Lewis L. Bennett, one of the best spinners of yarns ever to go whaling. Bennett commanded the *Hannibal* (built in 1819 in Sag Harbor, with an industrious 30-year career) and the *Sarah & Esther* (a Greenport bark) in 1845. This photograph was taken in May 1977; the house is a private residence today. (Courtesy Shelter Island Historical Society.)

The 350-ton whaleship *Thames* was built in 1818 as a freighter and passenger ship. After being sold as a whaler to W.R. and C. Hitchcock, she sailed for 12 years as the fastest ship from Sag Harbor. Capt. Huntting Cooper was master for five profitable voyages, after which his first officer, David Hand, took command. After a 20-year career, the *Thames* was scuttled and used as a breakwater. Her remains were rediscovered in 1968, and the keel has been reassembled at Mystic Seaport Museum.

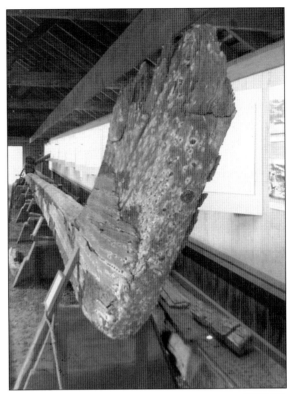

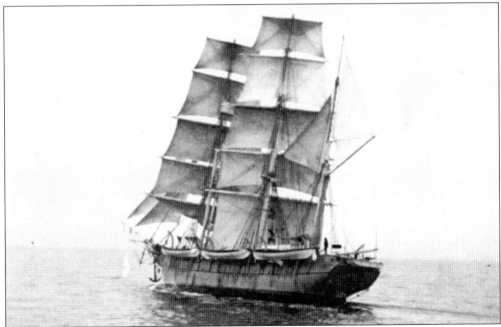

The North Shore's deep harbors allowed for the construction of larger ships. This is a platinum print of the whaling bark *Fleetwing* at sea. Built in 1877, she was one of two whaleships built in Port Jefferson for the New Bedford fleet; the other was the *Horatio*. Sailing mainly out of San Francisco, she was wrecked near Point Barrow in 1888. (Courtesy Mystic Seaport Museum.)

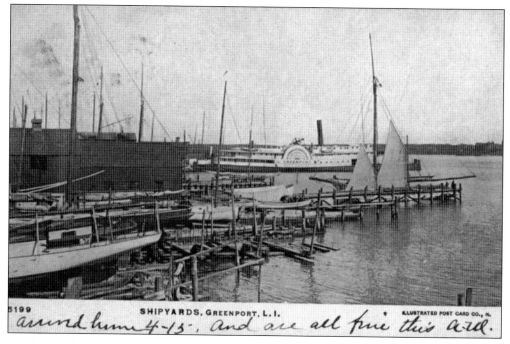

SHIPYARDS, GREENPORT, L.I.  5199  ILLUSTRATED POST CARD CO., N.

*around here 4-15-, and are all fine this a-rd.*

From 1795—when Capt. William Fowler led the *Minerva* from Greenport—until the last whaleship left in 1861, Greenport thrived with its protected, deepwater harbor and, as of 1844, rail transport. Greenport ranked 17th in the country in importance as a whaling port with its 25 vessels. These photographs of Greenport's shipyard (above) and Greenport Dock (below) were taken looking east in the 1890s. The whaling industry ushered in an era of prosperity and influenced the clustering of other Greenport businesses, including shipyards. In 1856, Greenport had 250 dwellings. Other buildings included six hotels, five churches, and four schools. (Both, courtesy Whitaker Historical Collection, Southold Free Library.)

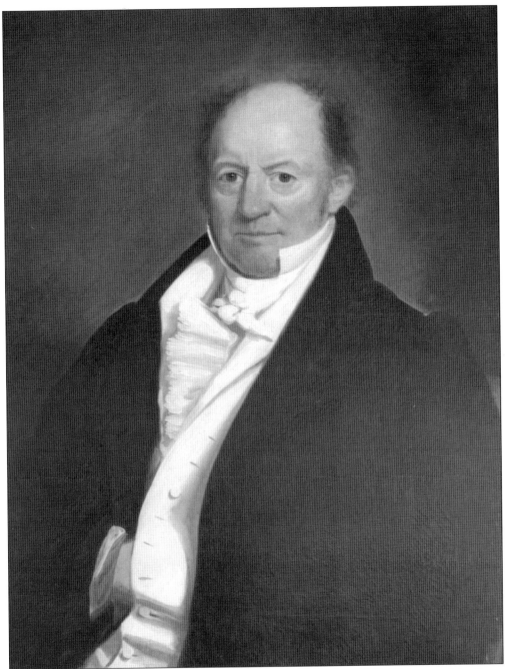

The Floyds of Mastic employed local Unkechaug Indians in the late 1600s. This portrait by Stony Brook painter Shepard Alonzo Mount shows Nicoll Floyd (1762–1852) around 1831. His father, William Floyd, signed the Declaration of Independence. Nicoll owned three whaleships at the time of his death, which he passed on to his son David. (Courtesy William Floyd Estate Archives.)

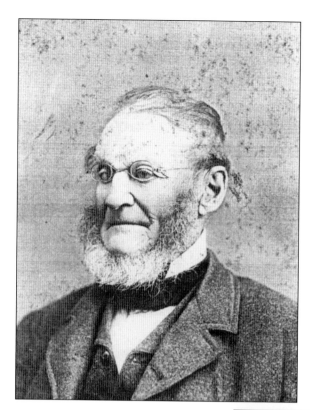

David Gelston Floyd (1802–1893) was a prominent and wealthy citizen, politician, and whaling entrepreneur in Greenport. He founded Floyd & Skillman, a ship chandlery, and owned the whaleships *Italy*, *Pioneer*, and *Prudent*. From 1847 to 1857, the three ships brought him about $400,000. (Courtesy William Floyd Estate Archives.)

In 1845, Floyd married Lydia Smith, a descendant of the prominent William Tangier Smith, and had four daughters. Here, he is playing dominoes—perhaps ones made of whalebone—with his granddaughter in Brecknock Hall. After the whaling industry waned in Greenport, Floyd turned towards the menhaden fish business. (Courtesy William Floyd Estate Archives.)

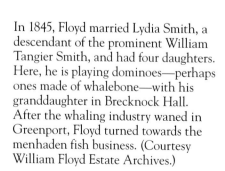

In 1845, Greenport employed 12 ships. Shown is a certificate of clearance for the *Italy* around 1846. She first sailed from Greenport in 1844. Capt. Frederick A. Weld of Sag Harbor wrote to the ship's owner, David G. Floyd, in Hawaii in 1845 that he had 1,400 barrels of oil and 10,000 pounds of bone, adding, "some ships have not got a whale this season." The *Italy* was later damaged beyond repair by a storm near Honolulu in 1858. (Courtesy Southold Historical Society.)

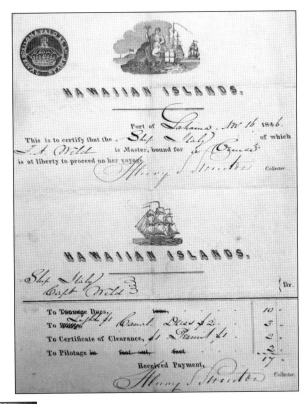

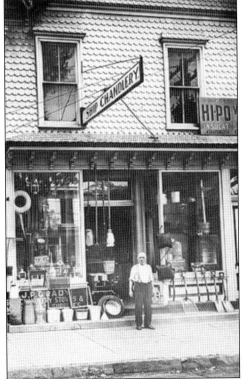

This Greenport store was located at 208 Main Street and was owned by James P. Grady. Among the many businesses to support ships, one of the key stores was a ship chandlery, specializing in retail and wholesale supplies for ships and crew. Items for sale included rope and cordage, tools, pitch, clothing, needles, canvas, navigational instruments, barreled food ingredients, and marine hardware.

WHEREAS, I *Joshua Pharaoh* Edward S Gray the Sum of *Fifty Six dollars & Forty Cents* with Interest until paid, for my Outfits as *Boatsteerer* on board the Ship or Vessel, called the *Pioneer Bark*, whereof *Babcock* is Master, and wish to secure *him* the payment thereof, I do hereby assign to the said *Edward S Gray* all such wages, share and proportion of money, oil and bone, or slush, as may accrue, result from, or be the consequence of my lay or contract in said Ship or Vessel, or in any other Ship or Vessel, in which I may contract to sail, from time to time, until the payment of such debt. **Also,** if, under any circumstances, I should leave the Ship or Ships, all such clothing and effects, of whatsoever kind, as shall be left, or the proceeds of the same, if sold. **To Have and to Hold** to *his* own use toward payment of the aforesaid debt, and also for all moneys or merchandize *he* shall advance to me and for me, up to the time of settlement of such voyage or voyages, and such debt. And also, all money *he* shall pay for insurance on said voyage or voyages, the overplus, if any, to be paid to me: And I require and authorize the Captain, Owners and Agents of said Ships or Vessels, to pay and deliver to the said *Edward S Gray* all such wages, share and proportion of money, oil, bone and slush, as may result or accrue to me, and do hereby make the said *Edward S Gray* my Attorney irrevocable, to demand, sue for and receive the same, hereby ratifying all *his* acts.

Dated ~~Sag-Harbor~~ *B Hampton* Oct 10. 1852    WITNESS MY HAND AND SEAL

**WITNESS**

*Egbert Halsey*

*Joshua* his ✗ mark *Pharaoh*

Pictured is an 1852 contract between Joshua Pharaoh and Edward S. Gray. Pharaoh worked as a boatsteerer on Greenport's *Pioneer* with Capt. Henry Babcock. Babcock later commanded the last voyage from Sag Harbor on the brig *Myra* in 1871. (Courtesy Southold Historical Society.)

Born in 1839, Portuguese whaler Manuel Claudio sailed from the Azores at the age of 12. He first visited Greenport in 1854 and saved his earnings to open Claudio's Tavern in 1870, which remains a family business today. He was successful and well known in the community. (Courtesy Claudio Family, Sterling Historical Society.)

Cold Spring Harbor came onto the whaling scene comparatively late, initially when foreign competition edged out the local woolen mill business. John H. Jones (1785–1859, right) started a whaling company with his brother Walter R. Jones (1793–1855, below), following in their great-grandfather's footsteps. They already owned a 1790 gristmill (inherited through a marriage to the Hewletts and powered by St. John's Lake; it burned in 1921), general store, and woolen mills before launching their whaling company and forming a whaling town. The Cold Spring Whaling Company owned nine ships, which sailed on 44 voyages to every ocean, though two vessels wrecked. Walter lived in New York City as president of the Atlantic Mutual Insurance Company, and John was the managing agent for the company, which operated from 1836 to 1862. When the brothers died, the company dissolved.

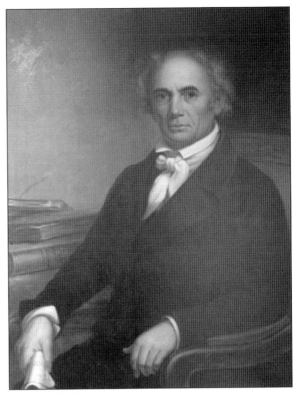

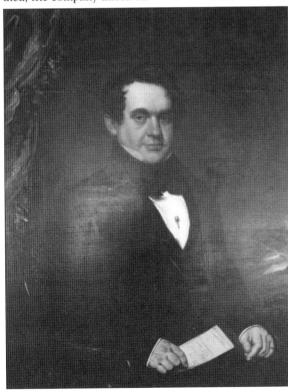

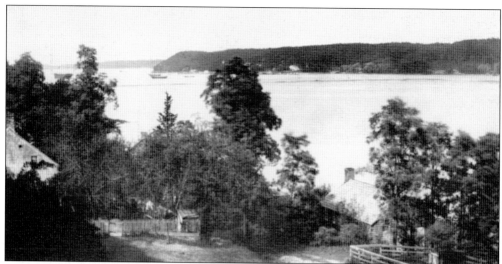

Cold Spring was a small village with a deep harbor. It became a port of delivery in 1799. Harbor was added to the village's name in 1826. This 1878 photograph shows a view of the harbor from the west. The renowned Cold Spring Harbor Laboratory was established here in 1890 on 100 acres formerly known as Bungtown. The Osterhout Cottage, a whaling-era building, is visible at upper left. (Courtesy Brooklyn Collection, Brooklyn Museum/Brooklyn Public Library.)

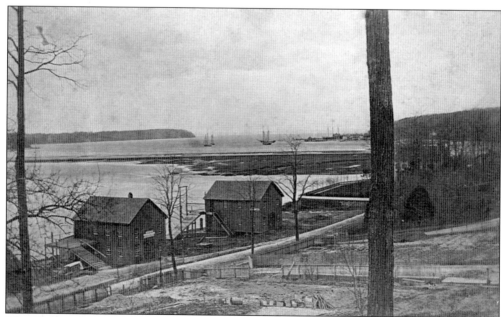

Though the whaling company's existence was brief, it was a local economic anchor, employing various merchants. Pictured are sail lofts in Cold Spring Harbor. The Jones family took advantage of their existing mills and cooperage to supply their ships. Eagle Dock can be seen in the distance, along with several sailing ships.

# WHALEMEN
# *WANTED.*

**Experienced and Green Hands are wanted for the Ship's of the**

# COLD SPRING WHALING COMPANY

**to sail from Cold Spring Harbor, Long Island. Apply immediately to**

### JOHN H. JONES, *Agent.*

*Cold Spring, 6th July,* 1839.

As seen in this 1839 advertisement, agents were always on the lookout for crewmembers willing to take on adventure: captains, mates, harpooners, coopers, carpenters, seamen, stewards, cooks, blacksmiths, and greenhands. Since many men shipping out did not have the money to pay for their supplies and clothing upfront, the agent would cover the cost, and the amount would be subtracted—with interest—from their pay at the conclusion of the voyage.

Bungtown School in Cold Spring Harbor was also known as the "nursery of sea captains." While there were native whalers from Cold Spring Harbor, no native captains commanded a Cold Spring Harbor vessel out of the 2,500 crewmembers who sailed from the port.

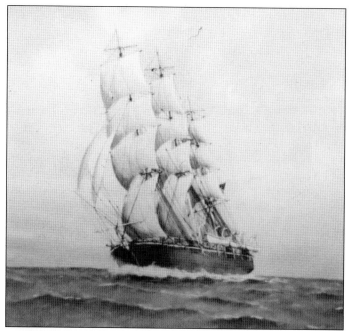

Cold Spring Harbor's *Huntsville* had an unusual U-shaped hull, which provided a generous 4,000-barrel storage space and also contributed to her speed. She was bought by John H. Jones in 1844 and remained in the company until 1858. Capt. William J. Grant's wife, who traveled with her husband, stayed in Honolulu in 1857 while the ship went on to northern waters, and she became good friends with Eliza Edwards of Sag Harbor's *Black Eagle*. Both boarded at a house in Honolulu kept by Mrs. Cartwright of Shelter Island.

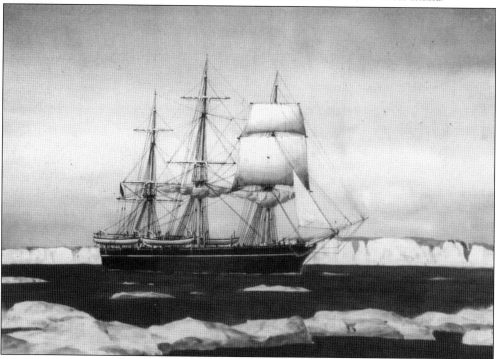

The *Edgar* was a Maine vessel built in 1844 as a packet ship but later converted to a whaler. She was used by Cold Spring Harbor from 1852 to 1855 for only one voyage captained by Samuel B. Pierson of Bridgehampton, who had previously captained the *Splendid*. He recruited much of his crew from his hometown. After shipping 195 bundles of whalebone (21,000 pounds) and 119 casks of oil from Honolulu, the *Edgar* headed to the Sea of Okhotsk, where she was wrecked in bad fog; however, much of the cargo was salvaged.

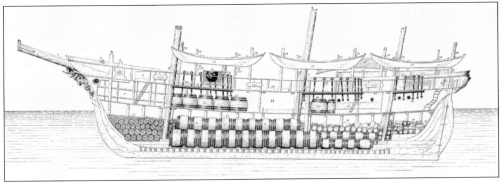

This image illustrates how whaleships were floating factories and warehouses. Shown is the interior plan of the whaling bark *Alice Knowles* of New Bedford, built in 1878. Tryworks boiled blubber into oil on-deck, while full barrels of oil were stowed below deck. At the bow is the foc'sle (forecastle), with tight bunk beds where the crew slept. At the stern is the captain's comfortable quarters. (Courtesy Fisheries and Fishery Industries of the United States.)

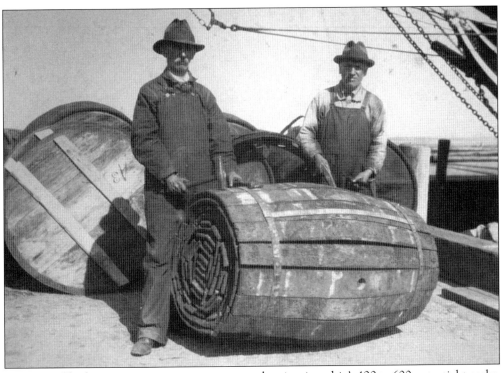

Every vessel had a cooper on crew to construct and maintain a ship's 400 to 600 watertight casks. Whale oil—along with food, water, and many other items—was stored in barrels containing 31.5 gallons. In the mid to late 1800s, the 42-gallon watertight barrel, weighing around 300 pounds, became a standard size. Here, coopers roll staves (planks), with the bung hole located in the center. At the time, native oak was plentiful and was used in the construction of barrels.

This sad image serves as a reminder that lost lives were not uncommon in the whaling business. Nathaniel Scudder of Huntington, born in 1833, sailed on Cold Spring Harbor's *Monmouth*. He was unfortunately lost at sea in 1855 with the second mate and an entire boat's crew when a whaleboat capsized.

Whalebone served as a raw material to create many kinds of utilitarian items, including canes, swifts, pie crimpers, sewing tools, dominoes, clothespins, cribbage boards, umbrella handles, and birdcages. Some pieces were quite simple, while others were elaborate. Pictured here is an overhead view of a whalebone basket.

Scrimshaw, an American folk art that originated in the late Colonial era, was a creative result of boredom when no whales were in sight. Sperm whale teeth were the typical canvas, polished and engraved during leisure hours, and whaling scenes and depictions of women were the most common themes. Most scrimshanders (scrimshaw carvers) remain anonymous.
This tooth is from the museum's collection, along with the items pictured on the next several pages.

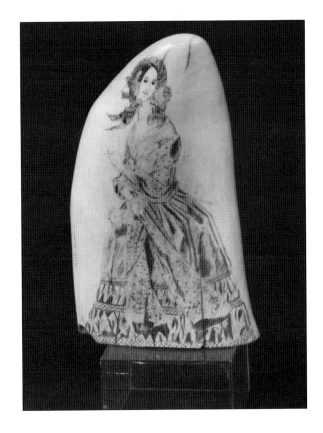

Shown here is a large and gloriously scrimshawed panbone, cut from the rear portion of a sperm whale's jaw. Whalers prized this piece of bone for the way its shape lent itself to be used as a canvas. In nature, many toothed whales use their lower jaws as antennae to transmit sound to their ears.

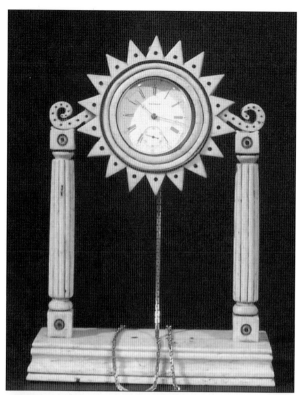

This beautiful watch stand was carved from whalebone. In the 19th century, wearing a watch on one's wrist was considered feminine, so men carried pocket watches. After a day at work, a man would rest his pocket watch on a stand such as this.

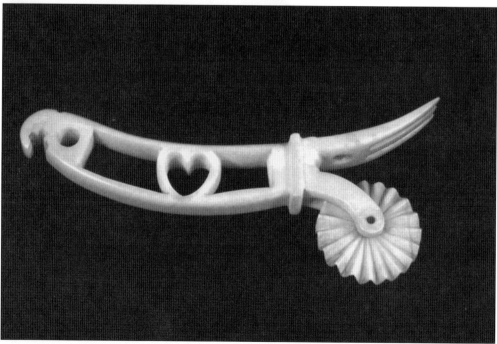

Jagging wheels (pie crimpers) were common baking tools carved by whalers from sperm whale teeth in the 19th century. The fluted wheel was used to create a decorative edge for pastries. While some jagging wheels were simple, others sported elaborate decorative shapes.

Women's fashion in the 1800s called for an upright posture and a very small waist. Corsets were worn, with whalebone supplying stiffness and shape. A flat, ruler-like piece called a busk kept the wearer straight and upright. Whalemen often carved designs into busks as a memento for their sweethearts, knowing they would be worn close to the heart.

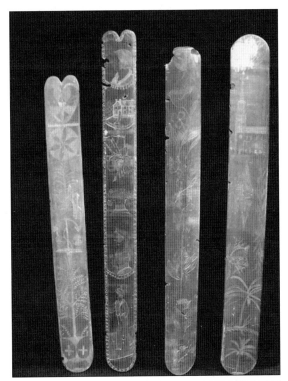

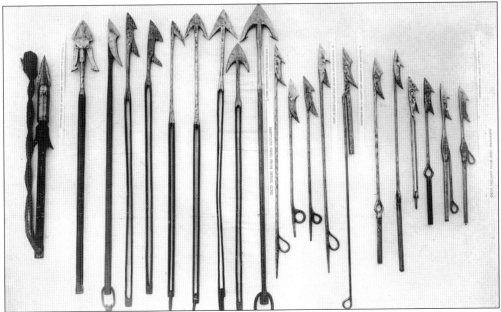

A whaleship on a four-year voyage would typically carry as many as 150 to 200 harpoons on board. The iron was about three feet long and was fitted into a long wooden base. The harpoon of choice was the toggle iron, whose barbs could pivot upon being embedded into blubber, resisting slippage. It was designed in 1848 by Lewis Temple, a free African American blacksmith working in New Bedford. His invention was widely replicated; however, he did not patent it, and he died penniless.

Aside from its use for high-quality (and expensive) illumination, sperm whale oil was used in ointments and cosmetic creams and as textile finishing and lubrication for machinery, including clocks and sewing machines. Nye, based in Massachusetts, was the last whale oil company in America. Today, the company manufactures synthetic lubricants.

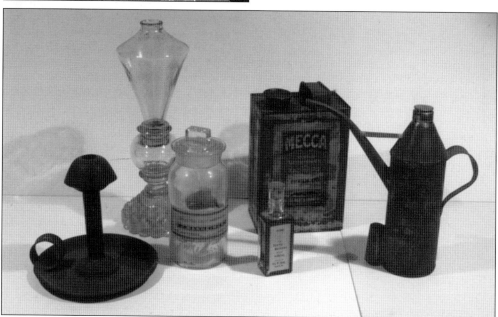

Of the fuels available at the time, whale oil was a top choice. Two-wicked lamps could be made of plain tin or ornate glass on a pedestal. From left to right are a candleholder, glass lamp, jar of ambergris, jug of sperm oil, whale oil for sewing machines, and oil filler can. Benjamin Franklin made an important improvement to whale oil lamps when he discovered two wicks placed together produced a brightness close to three flames.

# *Three*

# THE WHALE HUNT
## THAR SHE BLOWS!

Perhaps the most important tool of Yankee whaling was also its most brilliant innovation: the whaleboat. Other whaling technology improved over the years as harpoons gained flues and hinged barbs, ships increased their shape and tonnage, and rigging details changed to incorporate winch technology to reduce skill and manpower needed to handle sails; however, the real tool was the whaleboat, which saw minimal changes over time.

Technologically, the whaleboat was an example of mechanical prowess at sea. Built of cedar and oak and weighing only 700 to 800 pounds when empty, whaleboats were light and fast. They were also double-ended like canoes, which provided easy maneuverability and flexibility while at sea. This was imperative when trying to avoid whale flukes. The design was so successful that virtually every whaleboat used the same plan, and many were mass-produced in New Bedford. A typical whaleship carried four working whaleboats, with several spares. In 1852, there were more than 3,000 whaleboats used in whale hunts.

All of the photographs in this chapter were taken by ornithologist and naturalist Robert Cushman Murphy, a scientist and champion conservationist in his own right. Having grown up in Mount Sinai Harbor, he was freshly graduated and married when he was invited by the American Museum of Natural History to join one of the last sail-powered whaling expeditions on earth. He was primarily there to study birds of the South Atlantic, but he ended up documenting whaling as well. He later published his journal *Logbook for Grace*, which he kept for his wife, Grace. Among his many remarkable lifetime accomplishments, he was a cofounder of the Whaling Museum in Cold Spring Harbor.

These photographs portray the physical demands of whaling. No wonder 19-year-old Robert Weir, a greenhand, wrote on the second day of his voyage, "We have to work like horses and live like pigs." All the photographs in this chapter appear courtesy of the Whaling Museum & Education Center of Cold Spring Harbor and Mystic Seaport Museum.

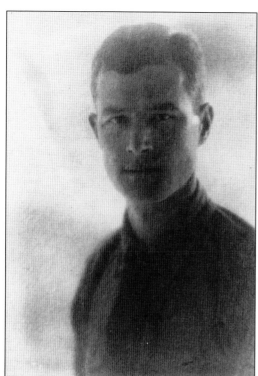

Robert Cushman Murphy (1887–1973) observed that the whale hunt was the most exciting day in his life. He also reported how whales and elephant seals were being overkilled, which would later play a role in strengthening whaling laws.

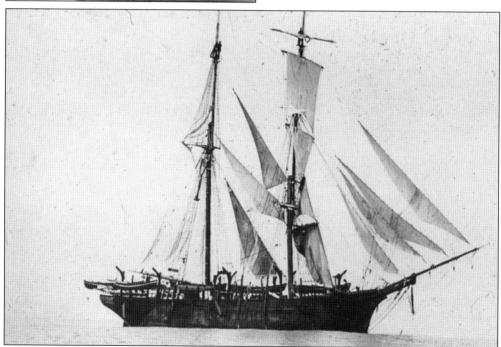

A particularly successful local shipbuilder was Nehemiah Hand of Setauket. With his son George, he completed the 439-ton *Daisy*, which was later converted to a whaler. The *Daisy* (pictured) embarked on one of the last sail-powered whaling voyages. She was lost at sea in 1916 as a merchant ship when she sprung a leak and sunk, with a bursting cargo of beans.

For two-to-four-hour shifts, two whalers stood in the ship's lookout stations, located high on the masthead, 100 feet above the deck. They waited to catch sight of a bursting spout in the monotonous landscape. Prizes, such as tobacco or money, often went to the whaler who first sighted a whale. Lookouts would also report sightings of ships, weather changes, and other wildlife. In this image, the greenhand on the right is Conrad Peters of Dominica, who eventually made it up to the masthead without fear.

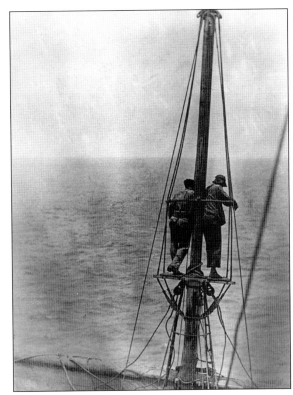

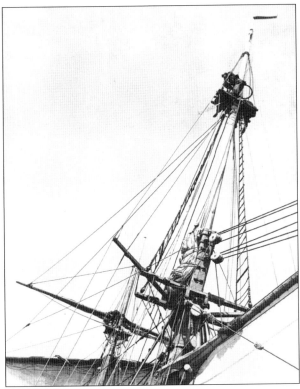

The mastheads are "the eyes of the whaleship." A pair of padded iron rings were clamped to the mast to form waist-high lookout hoops, where harpooner Francisco Nicolau scans the waters with binoculars.

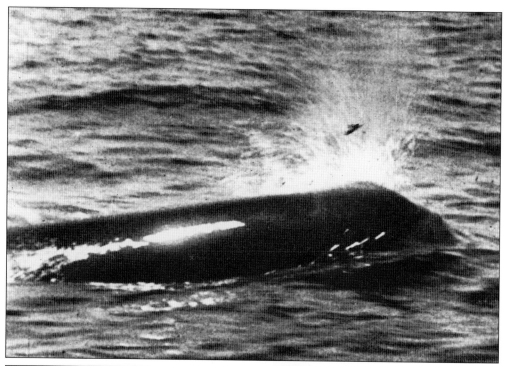

"Blows! Thar she blows! Dead ahead!" A sperm whale bursts to the surface after a deep dive. The crew quickly springs into action.

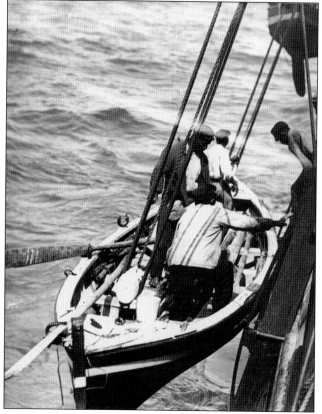

"Lower away!" After a whale sighting, the captain would give command to lower the whaleboats. Two or three were typically used in a whale hunt. It was important to team up in case one boat was capsized or wrecked by the whale.

There were always six men working in a whaleboat. Five would sit at their rowing positions, three to starboard, and two to port, while the sixth was the boatheader in charge. The harpooner, or boatsteerer, would sit at the bow. The wooden post around which whale line was wrapped was called the loggerhead, the light-colored square seen here to the right of the pulley.

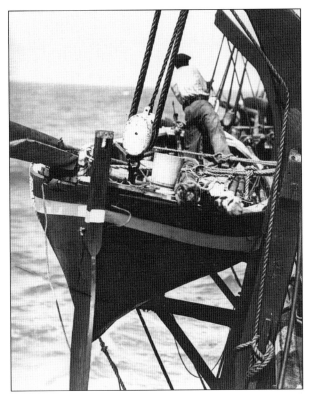

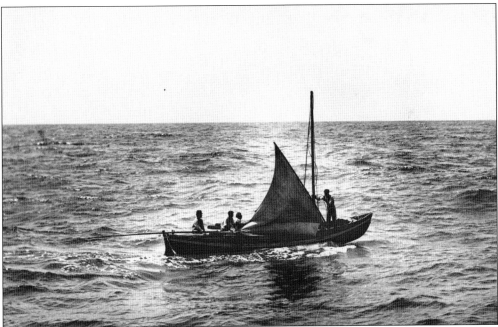

Whaleboats could move in one of three ways. If winds were favorable, the mast would be lifted onto a hinged platform and quickly folded when approaching action close to a whale. Whalers could also row single-banked with oars. Then, paddles would be used canoe-style when approaching the whale closely but quietly.

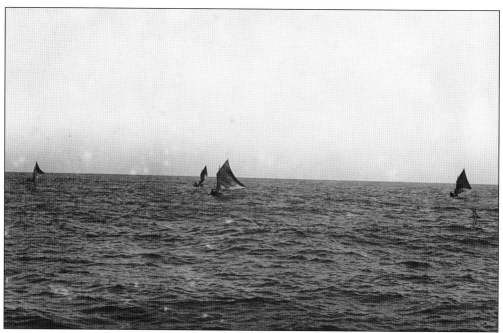

Four whaleboats are in pursuit, an almost peaceful scene before the fury of the hunt. Only about 10 out of a crew of 34 remain aboard the ship.

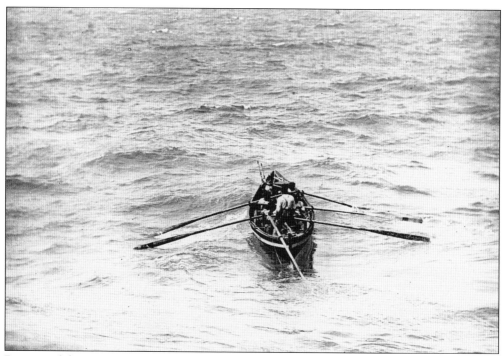

Because of the uneven rowing power inherent in having five rowing positions, the oar length varied between 16 and 18 feet in length to compensate. Oars were marked with one to five stripes at their tips, which designated rowing positions.

Lookout hoops were used not only to spot whales but to direct the men in the boats using flag signals, since it was difficult to see whales at a distance from the smaller boats. Here, Francisco uses colored waifs to direct whaleboats from afar.

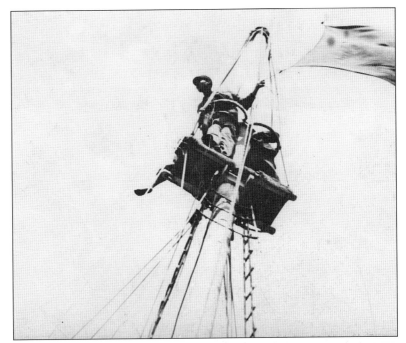

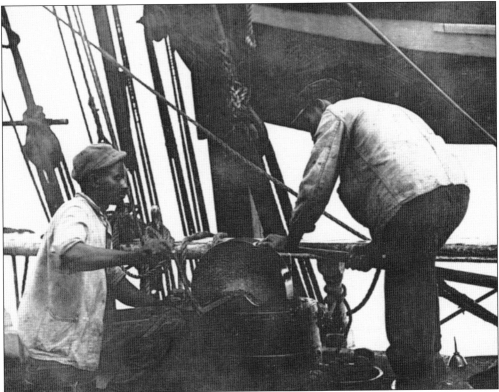

In the meantime, the cooper (barrelmaker) is busy polishing blubber spades, which are in constant need of sharpening. His assistant turns the stone. "Another sharp one, Cooper," was a common demand.

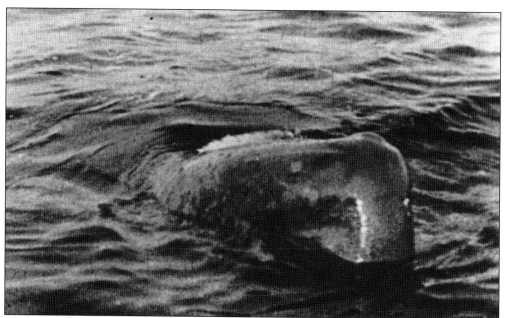

The whaleboat carefully approaches the whale. "Wood to blackskin!" is the command while coming as close to the whale's back as possible. At the boatheader's orders, the harpooner stops rowing, braces himself in the boat's clumsy cleat, and uses a strong arm and good aim to "give it to him" and harpoon the whale. If successfully harpooned, a "Nantucket sleighride" would ensue, where the whale would drag the boat, often for hours, until exhaustion.

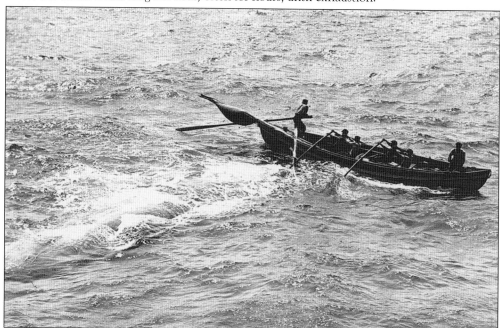

When the end of the whale's life was near, the harpooner and boatheader would switch places, and the boatheader would kill the whale by using a lance, which has a long, thin blade. In the event of an emergency (such as a quickly diving whale or a very angry whale), the harpooner would use an ax to cut the line free. As a last resort, a bomb gun was used in defense.

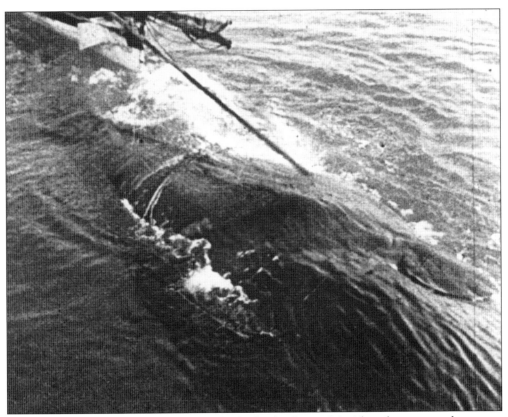

The sperm whale now floats, lanced and dead. The third mate, Mr. Almeida, prepares the carcass for towing, which is a slow, heavy drag back to the ship.

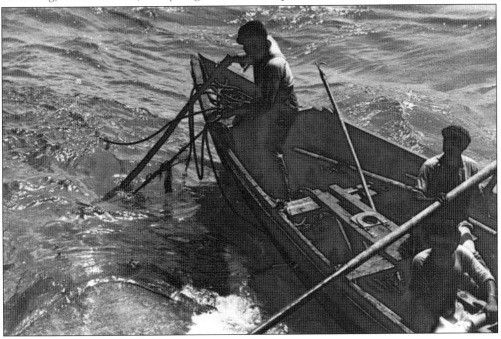

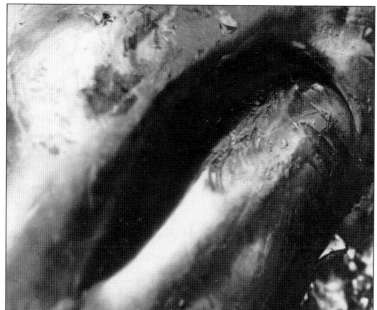

This photograph gives a close-up view of the blowhole. Baleen whales have two blowholes, whereas toothed whales, such as the one shown here, have one. The shape of a whale's spout—or exhaled cloud of air—indicates the individual species of whale. Strangely, the blowhole of a sperm whale is at an angle on the left side of its head. These whales can hold their breath for nearly two hours.

The crew works to secure the whale to the side of the ship. The captain (wearing the white hat) is shouting commands. Murphy's personal 17-foot Swampscott Dory, which he used to collect ornithological specimens, is hanging at right. Named *Grace Emeline* for Murphy's bride, the boat was designed for fishing near Cape Ann, Massachusetts.

68

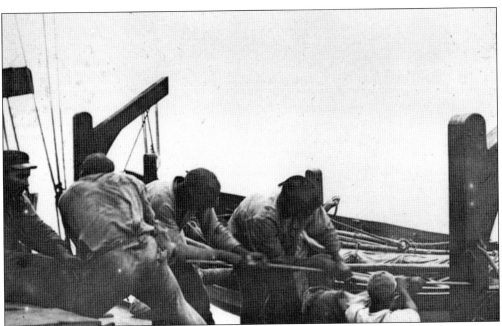

Men hoist the whaleboat, which hangs from the ship from a pair of crane-like posts called davits.

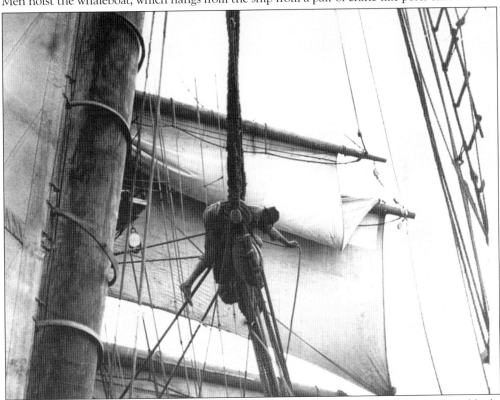

Harpooner Vitor Robinson of Brava Island prepares the cutting tackle, which comprises blocks from the main masthead that will raise enormous chunks of blubber onto the deck for processing. It was imperative to strip the blubber off quickly, as whales decompose internally quite rapidly.

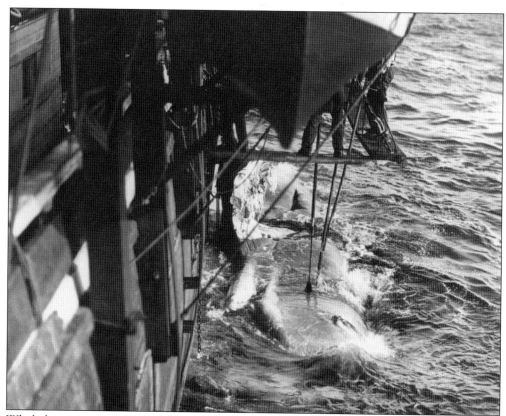

Whaleships were rigged with a 10-foot-long cutting stage, suspended over the sea by two planks. Mates would lean on the waist-high railing to separate the blubber and sever the head with spades. Below, John da Lomba, first officer, keeps weight off his painful left foot, the result of an accident.

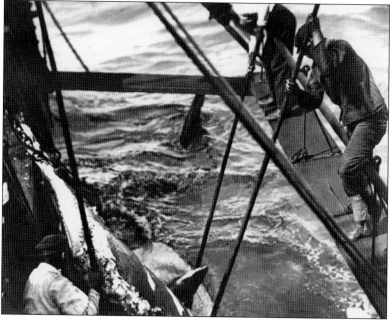

The boatsteerer, José Gaspar, dons a canvas "monkey belt" to secure himself. One can imagine the bravery required to stand on a giant, slippery whale in the shark-infested sea. A blubber hook was placed in the blubber near the flipper to peel it off in a large, spiraled piece. While the waters here appear black and white, in reality, they would have been a stunning red.

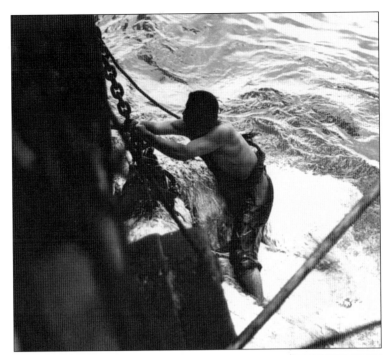

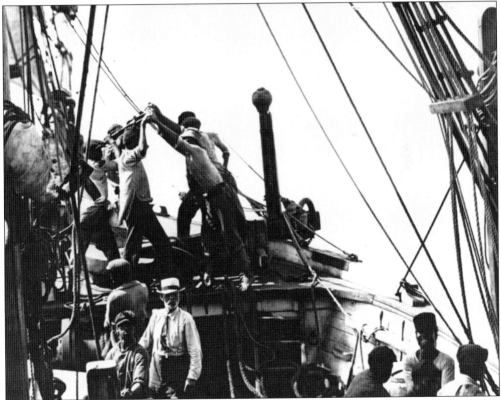

About half of the *Daisy's* crew works on the forecastle with the windlass to lift the blubber hook. Sea shanties (songs) were an important part of working to the same beat.

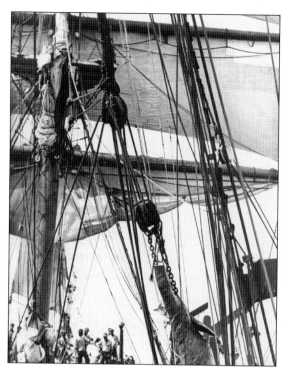

A large "blanket piece" of blubber, complete with the whale's right pectoral fin, is lifted onto the deck.

Murphy wrote: "Blocks may crack, stout ropes and the links of chains may part, but blubber holds." Blubber is more than just fat. It is a unique type of connective tissue containing many blood vessels. Blubber plays an important role in storing energy (especially for nursing mothers), insulation, and buoyancy.

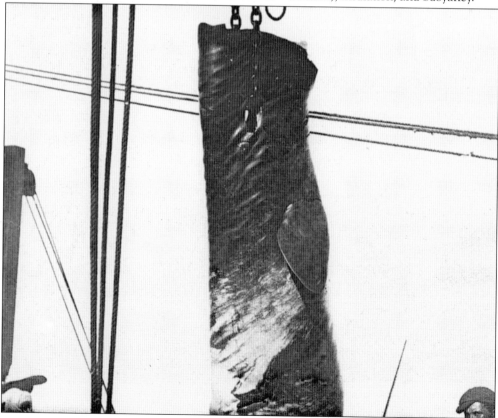

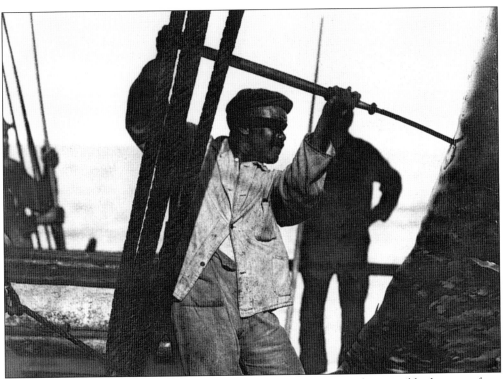

Mr. Almeida uses a boarding knife to cut a hole in the blubber, slicing the upper blanket piece free.

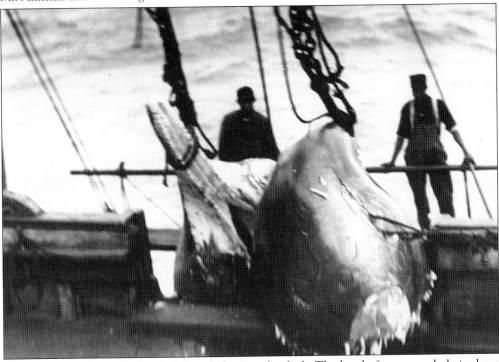

Men prepare to hoist the head of the whale onto the deck. The head of a sperm whale is about one-third of its body length.

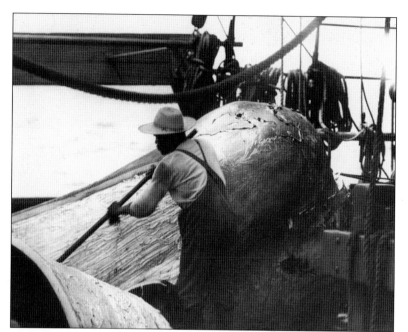

Pictured here is the head of the whale. A cavity in the whale's head holds the spermaceti wax. Mr. Almeida uses a spade to peel off the blubber.

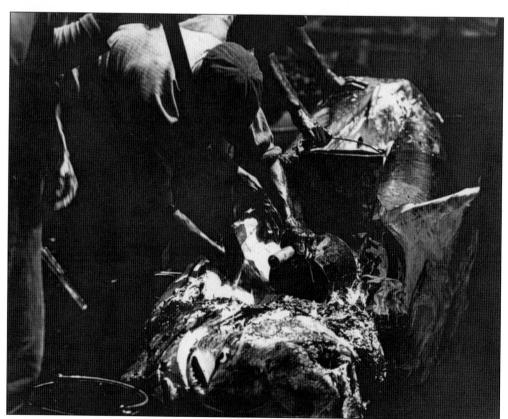

Here, the head of the sperm whale is being emptied of spermaceti wax, which was used to make high-quality candles. Workers use buckets to bail out the spermaceti.

The head of a larger sperm whale is too big to bring on deck, so the spermaceti is bailed on the side of the ship. Sperm whale oil was the finest of its day, reserved for lighthouses, streetlamps, and expensive candles, as well as a lubricant for machines. Sperm whale products continued to be used into the 1970s.

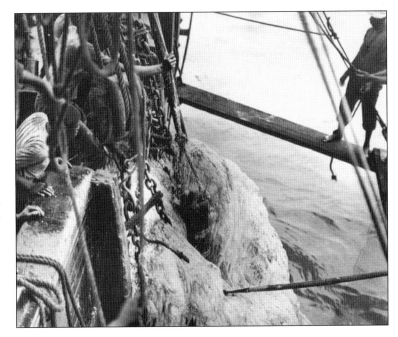

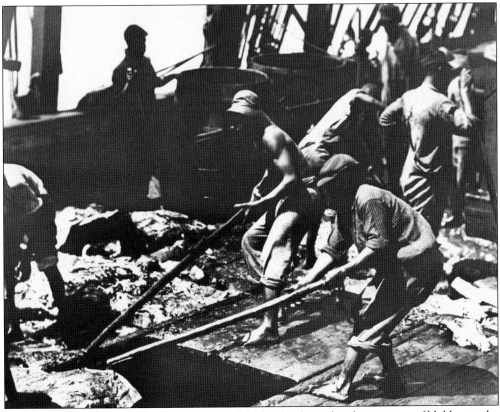

Freddy Lundy and Jean Paul of Dominica use blubber hooks to drag large pieces of blubber to the main hatch. The deck would have been quite slippery with grease.

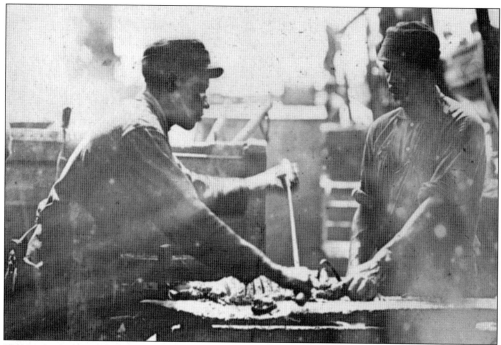

Blubber is cut into "horse pieces" and finally into "bible pieces," looking much like an open book before boiled in a trypot, which resembles a giant cauldron. Jean-Baptiste from Martinique (right), one of two sailors to die on the voyage, pushes blubber towards Ferleão from Brava.

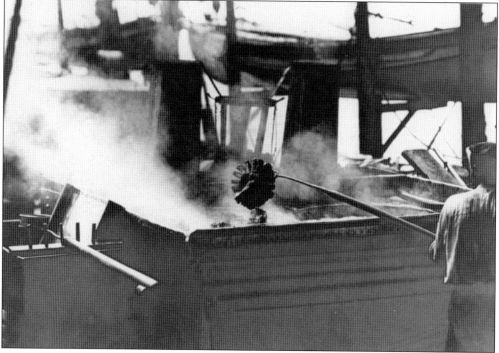

This photograph captures the process of extracting oil from blubber. When the crew hit a goal of filling a certain number of barrels, doughnuts were fried in whale oil as a reward.

When all the oil had been cooked out, the blubber fritters were lifted from the oil with a ladle-like skimmer, and the scraps were often used to feed the fire. The blubber essentially cooked itself. Here, trypots are seen from above.

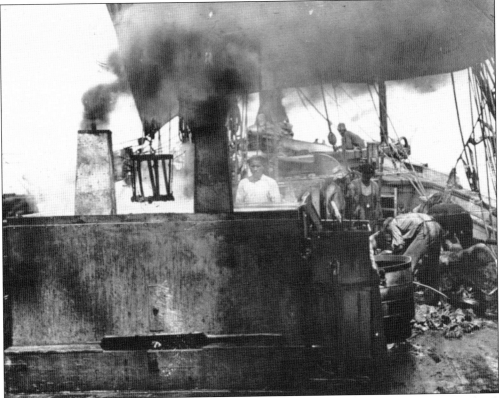

Thick, black smoke characterized whaleships, which were often smelled before they were sighted. The oil was cooled in cooling tanks (on the right) before being run through a canvas hose and barreled. Care was taken that not a drop was wasted. Even the deck drains were stopped up in case of a spill. Each crewmember was careful about conserving oil, as they were paid a percentage of the profits. Here, José Gaspar stands on the right.

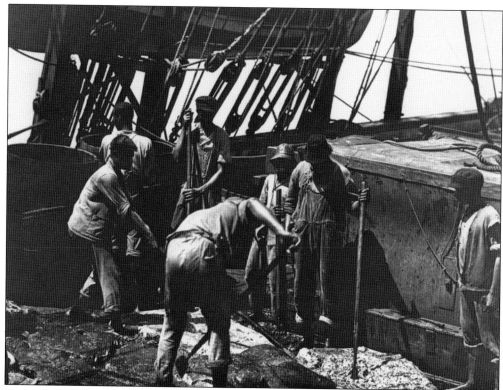

To say that whaling is filthy work is an understatement. One whaler wrote in 1856: "Everything is drenched in oil. Shirts and trowsers are dripping with the loathsome stuff. The pores of the skin seem to be filled with it. . . . you feel as though filth had struck into your blood, and suffused every vein in your body. From this smell and taste of blubber, raw, boiling and burning, there is no relief or place of refuge." What was used to clean the whale grease on the deck? None other than urine, contributed in a communal bucket over time by the crew.

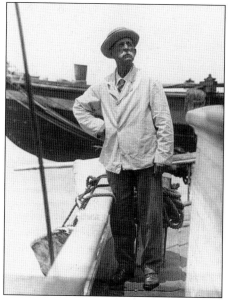

The scoured deck is now clean. The captain orders crewmembers back to the watch on the masthead, and the laborious process begins again. On to the next whale. One of the whales depicted in the preceding photographs yielded 80 barrels of oil and $1,200 in value.

Live animals were habitually carried on deck for meat on Sundays and holidays—notably pigs or roosters. Typically, a crew's rations included hardtack, salted beef and pork, beans, rice, potatoes, and molasses. Ironically, the crewmembers subjected to the hardest physical labor were the most poorly fed. Here, a lower whale jaw is tied to the side of the ship, likely a stockpile for scrimshaw.

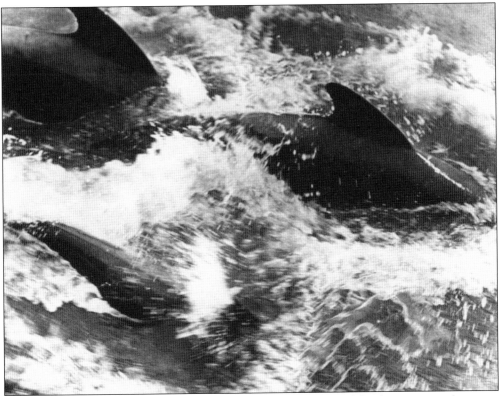

Rations on a whaleship were far from appetizing, with scum-covered drinking water and vermin-infested flour. Pilot whales (pictured) and dolphins were occasionally caught for meat, along with the random sea turtle, bird, or fish. Pilot whales, called blackfish, were also caught for their fine oil. One large blackfish might yield up to three barrels of oil.

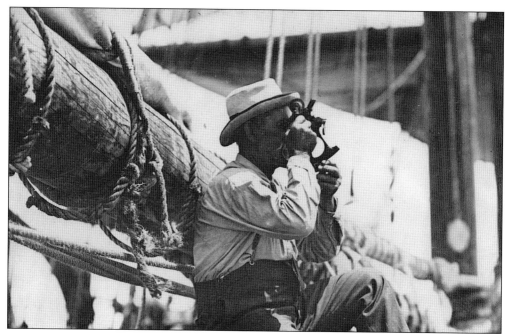

Captain Cleveland, known as "Old Man" (as many captains were called), "shoots the sun," using a sextant to gauge longitude and latitude at sea.

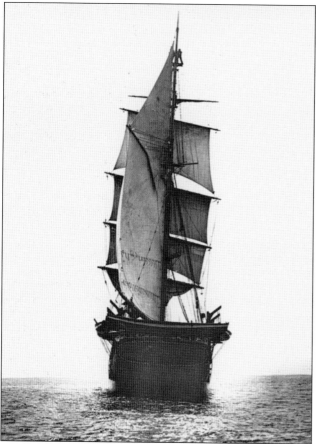

The *Daisy* is homeward-bound. Murphy published *Oceanic Birds of South America* and went on to a career as curator of birds with the American Museum of Natural History. He passionately led many conservation causes, including battling DDT and preserving Fire Island. A Long Island school and park have been named for him, as well as a feather louse, two mountains, a spider, three birds, an Antarctic inlet, a plant, and a fish.

# *Four*

# THE COMMANDERS
## AYE AYE, CAPTAIN

The star of the whaleship was the captain. In contrast to the meager earnings of lower-ranked crew members, the captain enjoyed improved wages, often receiving a share of 1/15, while a greenhand might earn 1/200. This was around triple what captains in the merchant service were earning at the time. Some continued from the lines of well-known whaling families, and others rose through the ranks from lowly cabin boys. The captain ate the best meals and enjoyed the largest living quarters—a stateroom in the stern of the ship. Many opulent homes of whaling captains reveal their fortunes.

From time to time, the captain would bring his wife and children along as an alternative to years of loneliness at home. One example of this was Capt. Smith Baldwin of Shelter Island, who brought his 23-year-old bride, Maria, on Greenport's *Roanoke*. She even learned to take the helm. Other wives were less enthusiastic when they found themselves "in circumstance" and were left in Honolulu to give birth. Martha Brown of Orient wrote, "My husband left me in one of the most unpleasant situation [sic] a Lady can be left in, without her husband, among strangers."

The captain's primary task was to direct the crew in finding, killing, and processing as many whales as possible in the shortest amount of time before returning with the bounty. The captain would also supervise the crew in sailing, maintaining the vessel, ensuring the ship was adequately supplied, and recruiting new crewmembers; desertion was common, and death at sea was a part of the business. Captains were decision makers, navigators, doctors, and surgeons, if necessary. They were the law enforcers as well; about a tenth of whaling logbooks in the 1840s document punishments, which would be performed in front of the entire crew.

Sag Harbor captain Jonas Winters wrote: "Sunshine and storm, surprise and disappointment, joy and sadness, never found better illustrations than were obtained in the whale fishery which was Sag Harbor's most important industry."

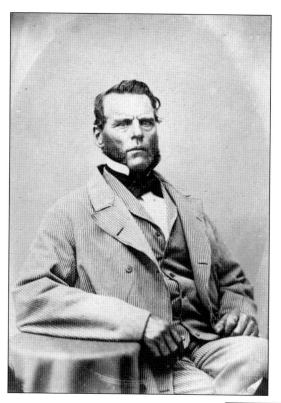

Capt. Edwin Peter Brown (1813–1892) was Orient's only whaling captain. Born in Oysterponds, he worked his way up to first mate and became captain by the age of 28. He successfully mastered the *Lucy Ann*, the *Amelia*, and the *Franklin*. On one voyage in 1843–1844, he filled his ship with 1,500 barrels of whale oil in 363 days, circling the globe without dropping anchor and setting a world record. He retired in the late 1850s to Orient and died in 1892. (Courtesy Oysterponds Historical Society.)

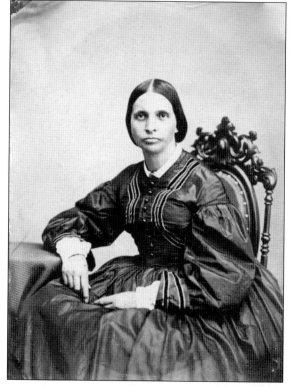

Captain Brown met his wife, Martha S. Brewer (1821–1911), in Brooklyn in 1843. Brewer was one of the brave wives to join her husband at sea, leaving her two-year-old, Ella, with relatives. She was quite unhappy at being left alone to give birth in Honolulu, and was resentful at being short on money. Brewer forbade Brown to leave her again, but he did. Her frank diary is a fascinating read of a woman's experience on a whaleship. (Courtesy Oysterponds Historical Society.)

The Brown house in Orient was large for a reason; the couple raised 10 children in it. After Captain Brown died, Martha turned the home into a boardinghouse for summer tourists. This photograph was taken around 1905 and shows "Grandmother Brown" in front. (Courtesy Barbara Hughes.)

Eliza Edwards of Sag Harbor joined her husband, Capt. Eli H. Edwards, at sea in 1857. She lived in Hawaii while the crew continued on to the Okhotsk Sea. There, she became close friends with women in similar circumstance and wrote many descriptive letters about Hawaiian life, which are in Mystic Seaport Museum's collection. She returned in 1860, when her husband was the first mate on Cold Spring's *Splendid*. Capt. Samuel Pierson graciously gave her his cabin. Her husband died in 1864 in an Army hospital in Kentucky. (Courtesy Audrey Hank.)

With a herculean physique and booming voice, Capt. James R. Huntting (1825–1882) of Bridgehampton loved to share wild whaling stories, such as when he was nearly dragged to his death by a sounding whale. As captain of the bark *Nimrod* in 1848, one of his whaleboats was attacked by a whale, and Huntting had to amputate a leg and crushed fingers from one of his crewmen; the man survived. Huntting retired in 1869. He and his brother Henry, also a whaler, were grandsons of Benjamin Huntting. (Left, courtesy Harper & Brothers; below, courtesy Collection of the Southampton Historical Society.)

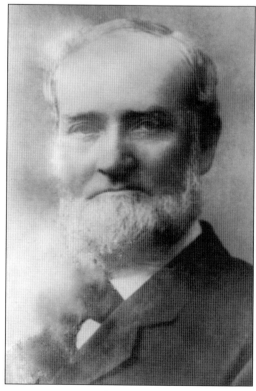

This 1835 portrait depicts the illustrious and perhaps best-known Sag Harbor whaling captain, Mercator Cooper (1803–1872), master of the 440-ton ship *Manhattan*. He was the first American to visit Japan in 1845 while rescuing Japanese crews from two disabled trading vessels, despite the strict anti-foreigner policy at the time. In 1851, he was also the first American to visit Antarctica. (Courtesy New Bedford Whaling Museum.)

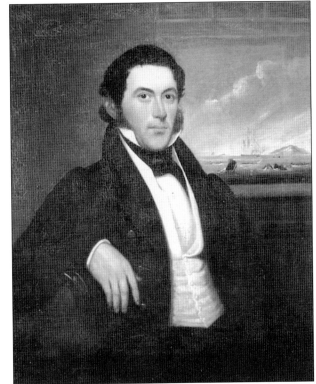

Built in the 1840s, Cooper's decadent home was built with the fortunes from whale oil. It is now part of Southampton's library. (Courtesy *Art & Architecture Quarterly/East End*.)

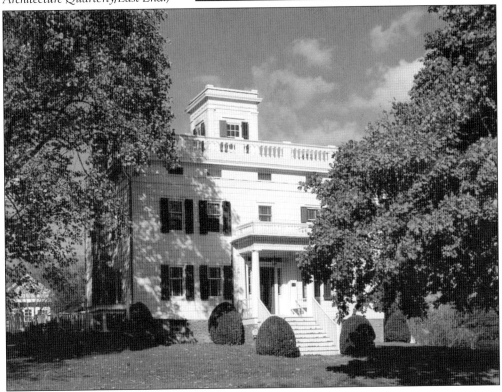

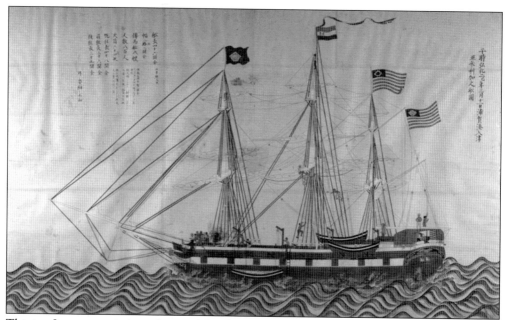

This is a Japanese artist's rendition of the ship *Manhattan*, painted in 1845. The *Manhattan* was the star of Long Island's perhaps most famous journey. One can imagine the mutual excitement felt by Cooper's crew and the Japanese at seeing such foreigners. (Courtesy New Bedford Whaling Museum.)

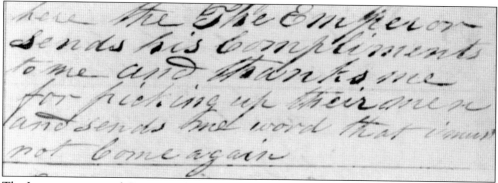

The Japanese presented Cooper with gracious gifts of food and gratitude but ultimately adhered to their isolationist policy. Cooper's entry for April 20, 1845, reads, "The Emperor sends his compliments to me and thanks me for picking up their men and sends me word that I must not come again." (Courtesy New Bedford Whaling Museum.)

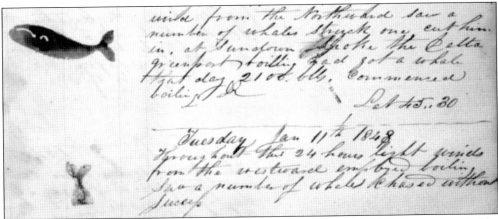

This detail from the logbook of the *Franklin*, commanded by Cooper, documents a catch (the whale) as well as a whale that got away (the flukes). The vessel was lost off the coast of Brazil in 1850 with a different crew. On his next and last voyage, Cooper journeyed from Sag Harbor in 1851 as captain of the *Levant*, this time on the hunt for seals as well as whales. He ended up discovering Antarctica on his journey. Cooper died in Colombia, South America. (Courtesy Long Island Collection, East Hampton Public Library.)

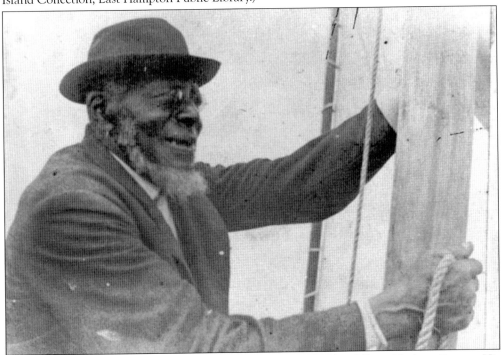

Pyrrhus Concer of Southampton was born in 1814 to the family of Capt. Nathan Cooper. His mother was a slave, and he was technically an indentured servant, but he was treated as a slave. He was sold to the Charles Pelletreau family for $25 at age five. Whaling was an integrated industry, and as a young man, he became a whaler. At age 18, he voyaged with Capt. Edward Sayre on the *Boston* in 1832 and on the *Columbia* with Capt. William Hedges. He then sailed with Mercator Cooper, the son of his first owner, on the *Manhattan*. He and some other whalers onboard were the first black men the astonished Japanese sailors had ever seen. (Courtesy Collection of the Southampton Historical Museum.)

After his adventure on the *Manhattan*, Concer returned to Southampton in 1847 and married Rachel Williams. In 1849, he sailed on the *Sabina* out of Sag Harbor in search of gold in California, though he presumably found none. When he returned, he had two sons, Charles and James (who unfortunately predeceased him), and began a ferrying business across Lake Agawam at 10¢ a ride, as seen here. He died in 1897. (Courtesy Collection of the Southampton Historical Museum.)

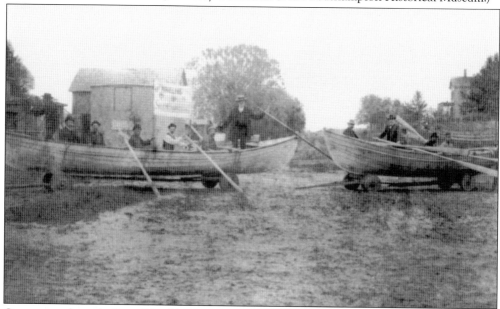

Concer stands out in Long Island history as someone who crossed race lines. In this photograph, he leads a float (far left) with other whalers when Southampton Village celebrated its 250th anniversary on June 12, 1890. Concer was known as a gentleman and was a well-liked person in the community. His obituary in the *Southampton Press* states he was "one of the most respected residents of the village" and "one of the links that bind Southampton to the past." (Courtesy Collection of the Southampton Historical Museum.)

Capt. David Hand was a particularly courageous individual and is likely the source of inspiration for the hero of James Fenimore Cooper's Leatherstocking Tales. Before the age of 20, he had seen George Washington, been a prisoner of war five times, and was an exchange prisoner from *Jersey* prison ships. When he captained Sag Harbor's *Salem*, 19 of the 28 crewmen were Long Islanders (two of them Shinnecocks). Hand had five wives and outlived them all. He died in 1840 and is buried with his wives. Hand's home, built in the early 1700s, is perhaps the oldest structure in Sag Harbor.

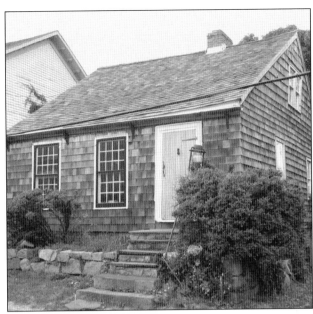

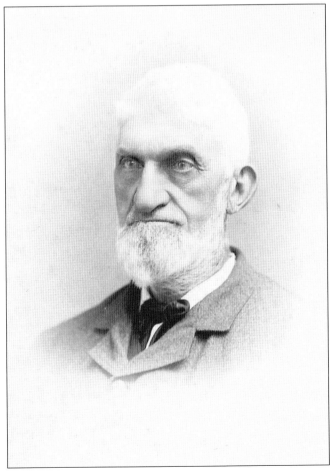

Adventurous George G. White (1819–1893) of Southampton grew from cabin boy to captain. He mastered the ship *Timor* of Sag Harbor and later searched for gold in California. A remarkably courageous person, he led a crew through a raging sea in a furious storm to rescue a wrecked vessel in Southampton. He was later elected president of the board of trustees in Southampton. (Courtesy Collection of the Southampton Historical Museum.)

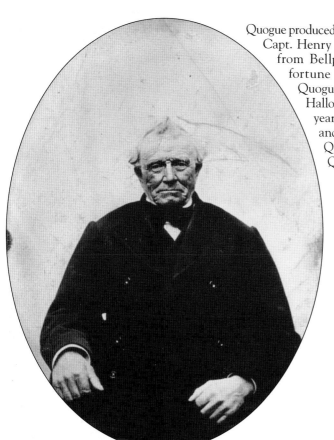

Quogue produced several notable whaling captains. Capt. Henry Gardiner (1789–1867, pictured) from Bellport settled with his whaling fortune in Quogue. Another notable Quogue captain includes Frederick M. Hallock, who followed the sea for many years, both in the whaling industry and merchant marine. He retired in Quogue and died in 1899. (Courtesy Quogue Historical Society.)

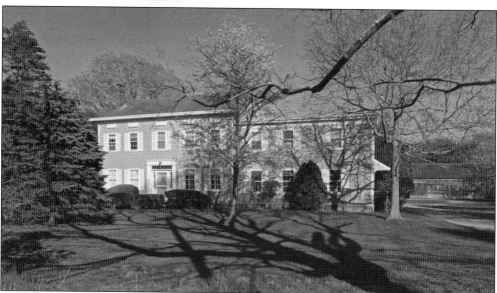

This 1820s Colonial house in Quogue belonged to Gardiner, who bought it for $625. A west portion of the house was added in the latter part of the 19th century. His son, also named Henry, converted the home into a boardinghouse. (Courtesy *Art & Architecture Quarterly/East End.*)

Gardiner's front porch was removed in the 1970s. (Courtesy Quogue Historical Society.)

Gardiner must have missed his wife, Polly, on his voyage of the *Dawn*, because he often wrote her name in the margins of the logbook, and she joined him on the ship's next voyage. Wives would fill hours with sewing or other handiwork. Polly cross-stitched a sampler on which she embroidered, "Bound to the Pacific Ocean in the ship *Dawn*. March 16, 1828."

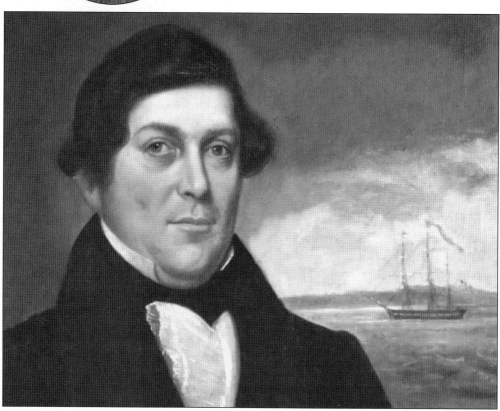

Capt. Barney Green (1835–1902) of Southampton went on his first whaling voyage on Sag Harbor's *Fanny* at the age of eight. At age 15, he sailed with his brother-in-law, Thomas Roys, on Cold Spring Harbor's *Sheffield*. He sailed around the globe twice on eight voyages over his 30-year career, becoming captain midway through his last voyage and suffering a bad injury from a whale. (Courtesy Collection of the Southampton Historical Museum.)

Capt. Albert Rogers was a prominent whaling captain from Southampton. During the Gold Rush, Rogers and other local whaling captains formed the Southampton California Mining and Trading Company and headed for California. (Courtesy Collection of the Southampton Historical Museum.)

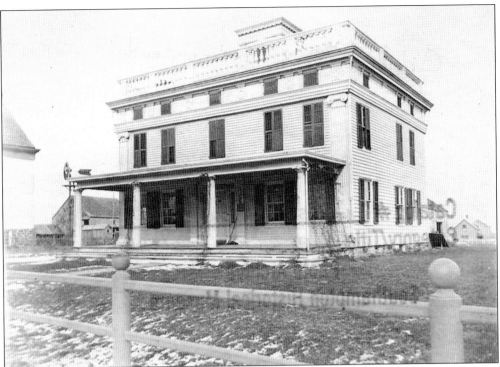

This 17-room mansion is perhaps one of the best examples of the opulent Long Island homes built from whale oil fortunes. At the age of 20, Rogers became the sixth generation of his family to live in this house; his ancestor William Rogers purchased the Southampton property in 1648. Albert Rogers later added the Greek Revival–style addition, showing off his grand wealth.

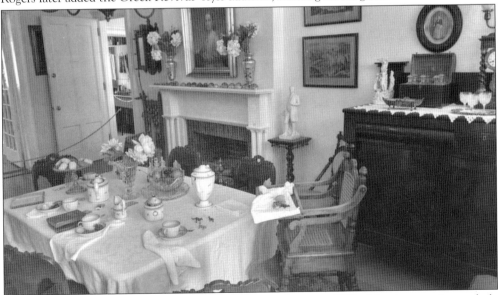

This is a representation of a family meal in the Rogers home in 1850. After harpooning a whale off Southampton, Rogers suffered a blow on the thigh from the whale's tail. Gangrene developed, and he died several weeks after. His son, Capt. Jetur Rogers, was the final Rogers to own the house. (Author's collection.)

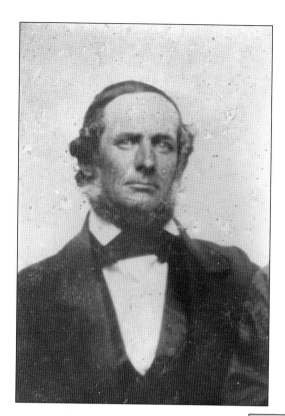

Capt. James Bishop sailed out of Sag Harbor on several vessels, including the *Ann* (1836–1839) and *Thames II* (1843–1849). (Courtesy Collection of the Southampton Historical Museum.)

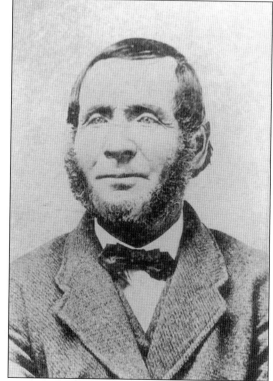

Capt. Edward Warren Halsey (1811–1871) lived on Hill Street in Southampton. Among the vessels he commanded was the *Tuscarora*, which sailed from Cold Spring Harbor and was the second ship in the company's fleet. (Courtesy Collection of the Southampton Historical Museum.)

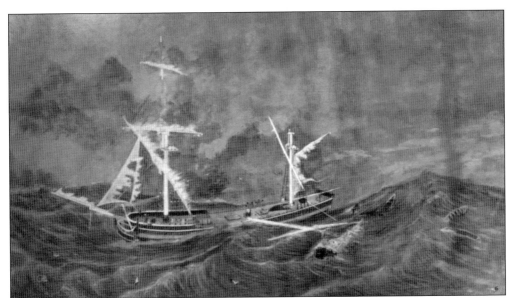

Built in 1819 by Robert Burton, the *Tuscarora* made 33 transatlantic round trips before being outfitted as a whaler. She sailed for Cold Spring Harbor on six voyages from 1837 to 1851. Under the command of Eli White, the ship hit a violent storm 1,000 miles southeast of the Cape of Good Hope. This 1841 painting shows the extensive damage; the insurance claim settlement was over $5,700.

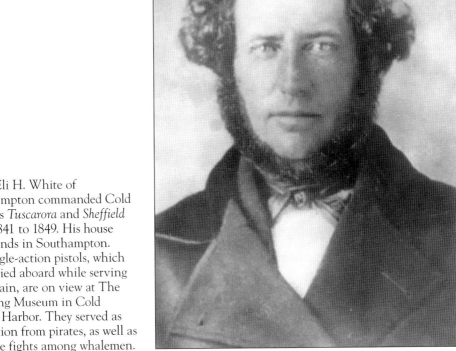

Capt. Eli H. White of Southampton commanded Cold Spring's *Tuscarora* and *Sheffield* from 1841 to 1849. His house still stands in Southampton. His single-action pistols, which he carried aboard while serving as captain, are on view at The Whaling Museum in Cold Spring Harbor. They served as protection from pirates, as well as to settle fights among whalemen.

During one voyage on the *Tuscarora*, a typhoon tilted the ship on its side, trapping Capt. Eli White in his cabin, who was praying as hard as he could. Thomas Edwin Warren (pictured), one of the mates, took a swig of liquor, passed it around to the crew, and cut away the masts and rigging so the vessel could right itself. (It did.)

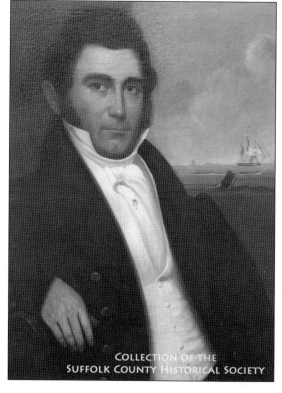

Capt. Henry Green was born in Sag Harbor in 1794. He went to sea for the first time aboard the ship *Fair Helen* in 1817. During his prolific career of 26 years, he captained the Sag Harbor ships *Abigail*, *Hannibal*, *Octavia*, *Phoenix*, and *Hudson*, along with Cold Spring Harbor's *Sheffield*. Capt. Henry Green is depicted in an 1824 oil painting by Hubbard L. Fordham of Sag Harbor. (Courtesy Collection of the Suffolk County Historical Society.)

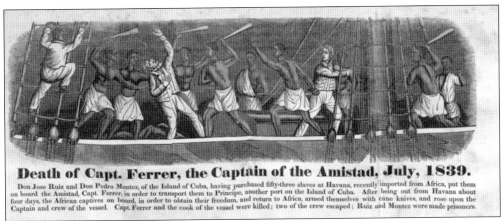

## Death of Capt. Ferrer, the Captain of the Amistad, July, 1839.

Don Jose Ruiz and Don Pedro Montez, of the Island of Cuba, having purchased fifty-three slaves at Havana, recently imported from Africa, put them on board the Amistad, Capt. Ferrer, in order to transport them to Principe, another port on the Island of Cuba. After being out from Havana about four days, the African captives on board, in order to obtain their freedom, and return to Africa, armed themselves with cane knives, and rose upon the Captain and crew of the vessel. Capt. Ferrer and the cook of the vessel were killed; two of the crew escaped; Ruiz and Montez were made prisoners.

On August 26, 1839, Henry Green was shooting birds when he came across the Spanish schooner *Amistad*, the site of a slave revolt. The Africans on board communicated that if they were supplied with provisions to return to Africa, Green would receive two chests of gold. The *Amistad* was ultimately captured but gained international attention. The captives were freed and returned to Africa. (Courtesy Barber, Hitchcock & Stafford.)

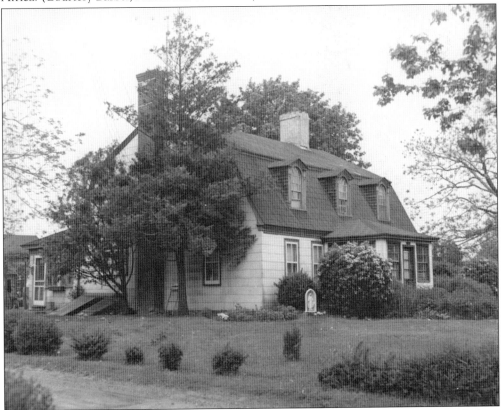

After losing $3,000 searching for gold in California, Capt. Henry Green moved his family from Sag Harbor to this new home, located on the north side of the Main Road, opposite Skunk Lane in Cutchogue. It was among a row of residences between Cutchogue and Peconic called "Blubber Row," occupied by retired whaling captains. Green died in 1873 and was buried in Sag Harbor. His home still stands today. (Courtesy Whitaker Historical Collection, Southold Free Library.)

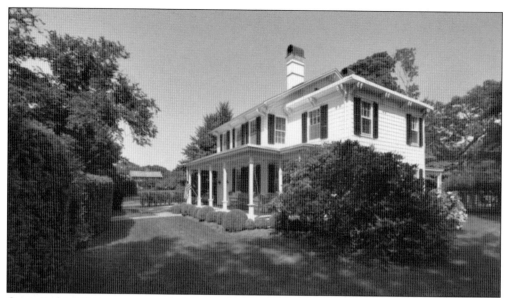

Capt. Ezekiel Howes commanded the bark *Camillus,* which sailed from Sag Harbor in 1840. Around 1850, Howes built this Greek Revival home in East Hampton, where he retired with his wife, Hannah Osborne. Originally one story, the house was later enlarged. Their only daughter, Ellen, was born in 1854. Unfortunately, Hannah died young, and Ezekiel later married one of her sisters. This is a private residence today. (Courtesy *Art & Architecture Quarterly/East End.*)

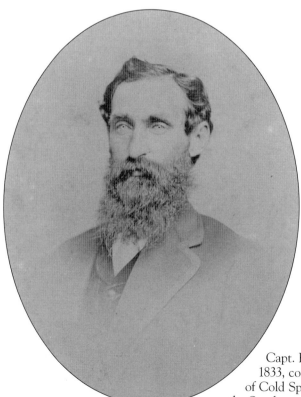

Capt. Elias White of Southampton, born in 1833, commanded the *Alice,* which sailed out of Cold Spring Harbor. (Courtesy Collection of the Southampton Historical Museum.)

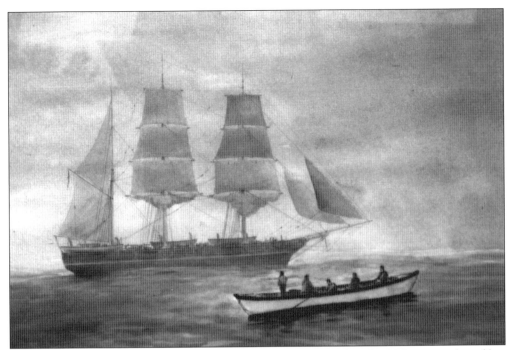

The *Alice* was built in Newbury, Massachusetts, for coastwise trade. John H. Jones purchased her for Cold Spring Harbor in 1844. She went on six whaling voyages, including Cold Spring Harbor's last in 1858, which lasted 44 months.

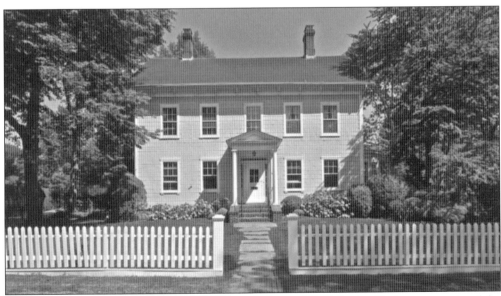

Capt. Jeremiah Mulford of a seafaring family sailed out of Cold Spring Harbor as captain of the *Nathaniel P. Tallmadge*. He had this stately house built around 1860 in East Hampton. The home is a private residence today. (Courtesy *Art & Architecture Quarterly/East End*.)

The *Nathaniel P. Tallmadge* was a particularly successful whaler for Cold Spring Harbor. She made four voyages between 1843 and 1855, bringing in a total of 8,410 barrels of whale oil, 245 barrels of sperm whale oil, and 53,390 pounds of bone.

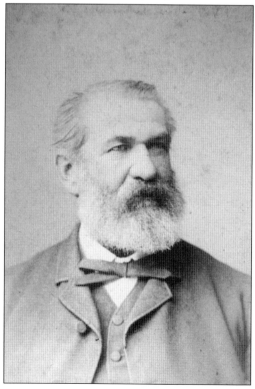

Capt. Dewitt Barrett was one of three Cold Spring Harbor whaling brothers. The oldest, George, rose through the ranks to become captain, while the youngest, Freeman, was caught in a line and dragged by a whale, dying after reaching home. Dewitt first sailed on the *Splendid*, which did not catch one whale for seven months until sailing into the Bering Strait, where 2,000 barrels of oil were tried out in less than two months. After the Cold Spring Whaling Company closed, he commanded New Bedford's *Sunbeam*. His home stands on Main Street in Cold Spring Harbor.

Capt. Jetur R. Rose (1824–1894) of Southampton sailed with his family as he captained six different ships. At one point, he nearly faced mutiny. When one burly crewmember threw a cask of butter overboard in protest of the bad food, Rose promptly tossed him overboard after it. He and his cousin caught a right whale off of Sag Harbor's South Beach in 1882, producing 30 barrels of oil. He left retirement to captain a new steam whaler built in New Bedford on its inaugural voyage to the Pacific.

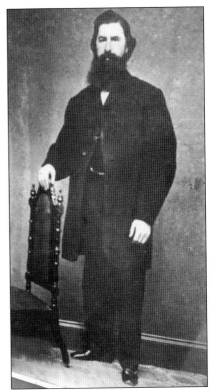

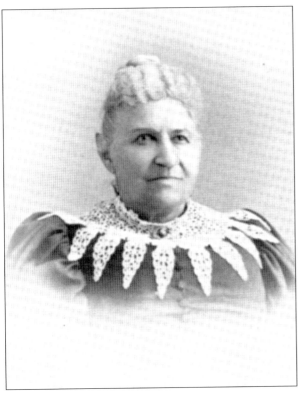

Caroline Rose (the "Belle of Southampton") sailed with her husband, Captain Jetur, for 15 years. She gave birth to her only child, Emma, in Honolulu in 1856, who was raised at sea. The cabin boy, Sidney Rhodes (pictured on next page), often played with her daughter and called Caroline and Jetur "the finest people he had ever met." (Courtesy Southampton Historical Museum.)

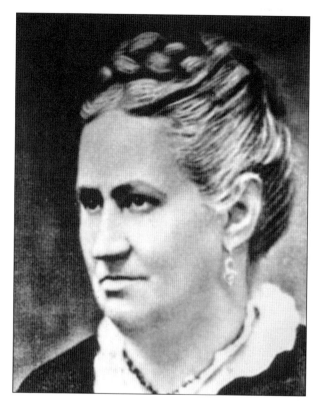

Captain Jetur and Caroline's daughter, Emma, logged thousands of miles before her 13th birthday. She wrote in her diary when she was eight, "Father shot a white bear yesterday, and we have got another whale." During one hunt, she witnessed the near death of the second mate after he was dragged by a whale. When a missionary came on board to try to educate Emma, claiming no one on a whaler knew anything, Emma told her, "I know the Ten Commandments and multiplication table, and that is enough for any little girl to know."

Sidney Rhodes sailed with Captain Rose as a cabin boy on the *Zenas Coffin*, a Nantucket ship that sailed from Sag Harbor in 1854. Although treated well, he became sick of the sea and deserted the ship with two other crewmembers in Chile. He was caught and returned to the ship expecting a licking, putting on two pairs of pants for the expected punishment; however, the ship immediately caught five whales and needed every hand available. A week after, Captain Rose said, "Boy, those whales saved your hide." In this photograph, he is age 19 and a boatsteerer on the *Columbia*.

Capt. Aaron Cuffee, of Indian descent, was rescued from a shipwreck in the Arctic on the *William Tell* of Sag Harbor in 1859. He later captained the *New London*, a Sag Harbor steamship. His fashionable facial whiskers and fine clothing in this photograph speak to his prosperity. Cuffee's homestead was in the woods between East Hampton and Sag Harbor. He is the only whaleman of Indian descent to have scrimshaw displayed in a museum (Sag Harbor). (Courtesy Long Island Collection, East Hampton Public Library.)

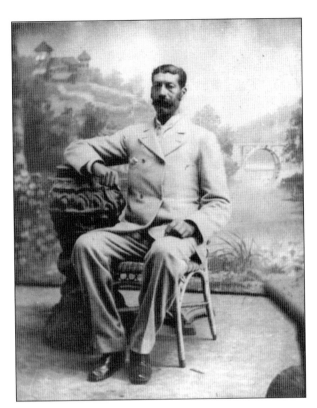

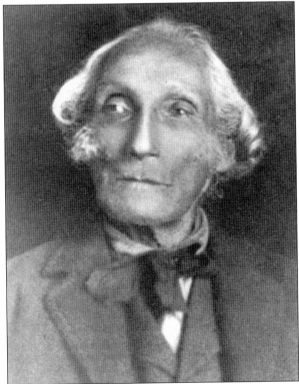

Wickham Cuffee, born in 1826, was the son of Sarah Bunn and Vincent Cuffee. He was a well-known whaler, nicknamed "Eagle Eye" for his ability to spot whales at a great distance. Cuffee was well versed in tradition, and his memories of earlier Shinnecock life were of much value to ethnologists and historians. (Courtesy Long Island Collection, East Hampton Public Library.)

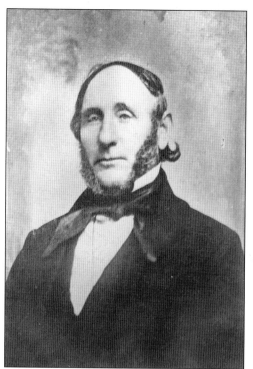

Jesse Halsey Lane in Sag Harbor was named for Capt. Jesse Halsey (1769–1840). He commanded several Sag Harbor ships, including the *Xenophon* (1835, 1838, and 1840) to the South Atlantic, and the *Franklin* (1841) and the *Alciope* (1844) to New Zealand. He also commanded a ship out of Greenport in 1847, the *Caroline*, which whaled off the northwest coast. (Courtesy Collection of the Southampton Historical Museum.)

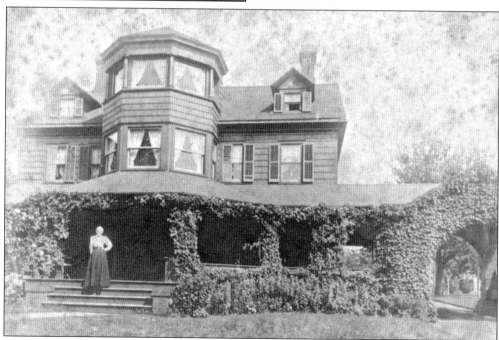

Capt. Isaac Ludlow (1807–1871) went to sea at the age of 15. He made 20 voyages on whaling ships, many of them as captain from Sag Harbor. As captain of the *Monmouth* from Cold Spring Harbor, he rescued 105 people from the British bark *Meridian* in the Indian Ocean in 1835. He retired with a fortune at this home in Southampton. (Courtesy Mary Cummings, Southampton, Images of America.)

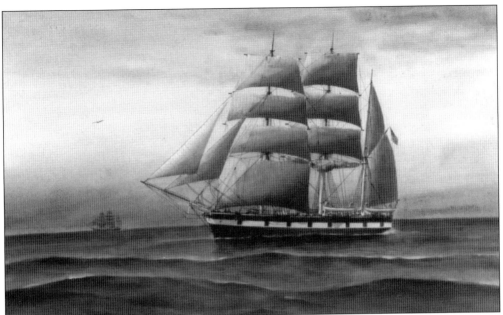

The *Monmouth*, the star of Ludlow's rescue, was Cold Spring Harbor's first and smallest ship at 100 feet long. Built in 1825 by John M. Robertson in Massachusetts, she was purchased in 1836 by John H. Jones with an investment of $20,000 collected from 33 friends. Her first voyage was out of Sag Harbor under the command of Richard Topping. Additional voyages followed to the South Atlantic, but profits on those voyages were marginal.

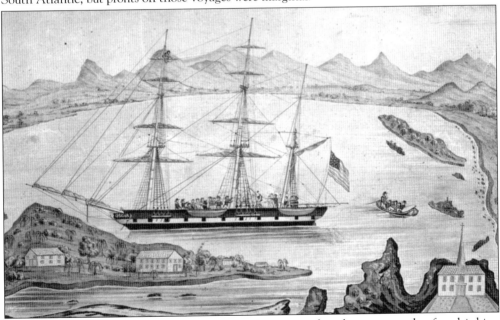

Ludlow also faced mutiny. Several of the *Oscar's* crewmembers became unruly after drinking smuggled rum off the coast of Brazil in 1845 and threatened violence. Ludlow, fearing mutiny, shot the ringleader, as depicted in this print. Ludlow was acquitted, and two instigators were jailed. Ludlow returned home to Cold Spring Harbor and continued his whaling career. (Courtesy New Bedford Whaling Museum.)

CAP'N ENOS

Capt. Manuel Enos (1827–1915), known as "Big Manuel," was born in 1827 on the Azores Islands. He rose through the ranks as he sailed on Cold Spring Harbor's *Hunstville* and *Sheffield* and later as captain of New Bedford's *Java*. He married local Susan Brush and settled in Cold Spring Harbor, where his house still stands today. His onshore business did poorly, spurring him to return to sea. He was thought lost at sea until recently, but was lately discovered to have started a new life in Chile.

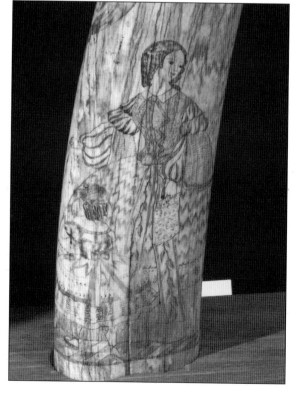

Enos is considered one of the best scrimshanders in whaling history. This is an example of one of his creations on a walrus tusk. The woman is believed to represent his wife, and she holds a sheet that says "*Java*, Capt. Enos," referring to the ship he commanded. The little girl at her skirt is his daughter, Melva, who unfortunately passed away while he was at sea.

This recently resurfaced photograph is of Capt. Jonas Winters (1813–1894), a well-known whaler who sailed from Sag Harbor and ascended from the rank of sailor. He went on 11 voyages and was master of the ship *Romulus* (1845) and the three barks *Elizabeth Frith* (1848), *Charlotte* (1850), and *Excel* (1857). Over his lifetime, Winters accumulated 24,500 barrels of oil and 244,000 pounds of bone. Several of his eight brothers often joined him at sea, and he had six children with his wife, Emeline, who also sailed with him. (Courtesy Morgan Peart.)

While captain of the *Elizabeth Frith*, Winters came across the shipwrecked *Richmond*, captained by none other than his younger brother Philander Winters. While there was no initial loss of life, Philander was affected so negatively by the shipwreck he later died at sea. Meanwhile, Jonas had left his wife, Emeline, in Hawaii to give birth to their second child.

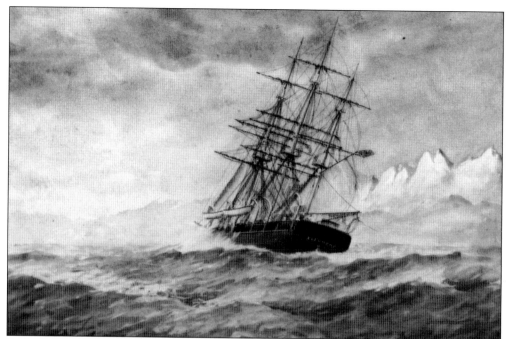

Built in New York City in 1825 and converted to a whaler in 1843, the *Richmond* (above) left for her second Cold Spring Harbor voyage in 1846 on a 37-month journey that would end in a shipwreck. The logbook's last entry is from August 2, 1849. It notes that while cruising for the very last whale needed, the ship struck a reef in thick fog at 3:00 p.m. near the Bering Strait. All crew members managed to escape to shore. Two days later, three ships in the area—the *Elizabeth Frith*, the *Panama*, and the *Junior*—rescued the crew and recovered much of the bone and oil from the sinking ship's hold. The Cold Spring Harbor Whaling Company filed a lawsuit eventually resolved by the Supreme Court, which ruled one who saves the cargo from a distressed vessel cannot keep it all. This salvage law remains in place today. Pictured below is an 1846 contract for a crewmember on the *Richmond*.

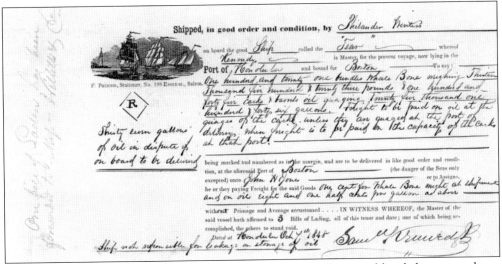

The museum in Cold Spring Harbor recently acquired a large collection of detailed correspondence regarding the *Richmond*'s voyage; shown is one example. Philander Winters had stopped in Honolulu in October 1848 to ship part of his cargo to John H. Jones in Cold Spring Harbor, as seen in this shipping paper, which lists 120 bundles of whalebone weighing 13,500 pounds and 145 casks of oil totaling 25,100 gallons. The freight was paid for in a portion of oil (1¢ for whalebone, and 8.5¢ per gallon for oil).

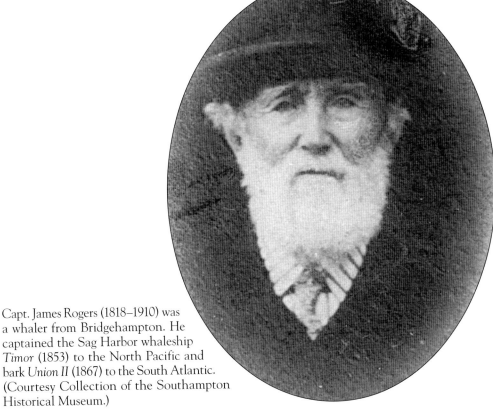

Capt. James Rogers (1818–1910) was a whaler from Bridgehampton. He captained the Sag Harbor whaleship *Timor* (1853) to the North Pacific and bark *Union II* (1867) to the South Atlantic. (Courtesy Collection of the Southampton Historical Museum.)

Born in Southhold to a whaling family, Capt. Oscar Worth (1860–1907) moved to Bridgehampton and built this home in 1882. He married Martha Huntting, daughter of Capt. James Huntting, a well-known local whaling captain. Worth named his home after his father's whaling ship, the *Konohassett*, which sunk in the Pacific Ocean in 1846. This home was badly damaged in the 1938 New England hurricane and was razed.

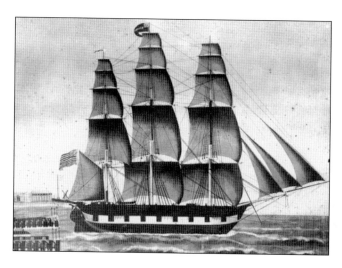

The *Konohassett* was formerly a Boston merchant ship. She joined the Sag Harbor whaling fleet and set out for her only voyage in 1845 with Capt. James B. Worth, during which she struck a reef on Pell's Island. The ship, insured for $30,000, was a total loss, but no lives were lost. Captain Worth's crew constructed a sloop from the wreckage called *Konohassett Jr.* and, armed with only bread and water, sailed to Hawaii in 42 days. (Courtesy Cohasset Historical Society.)

Capt. William H. Payne (1809–1893) was another well-traveled whaling captain sucked into the Gold Rush. In his career, he commanded the *Electra*, *Portland*, and *Wicasset*. As commander of the *Thames II* of Sag Harbor in 1849, he sailed into San Francisco with nearly 2,000 barrels of oil. Both the oil and vessel were sold at that port. (Courtesy Collection of the Southampton Historical Museum.)

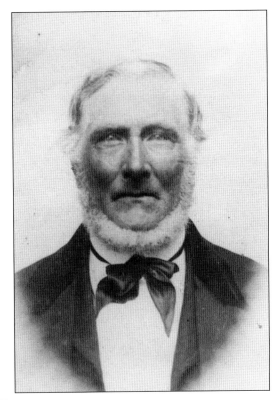

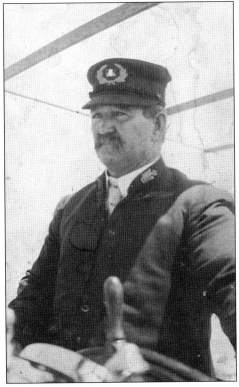

This photograph was confirmed to be of Capt. Selah Darling (1860–1941), taken by his granddaughter Amy Russell of Port Jefferson. Darling was born in Northport in 1860 and began his career on whaling ships as the industry was in decline. He later ran schooners to Nova Scotia and moved to Port Jefferson. He retired in 1927. (Courtesy Kathleen Cash, Port Jefferson Historical Society.)

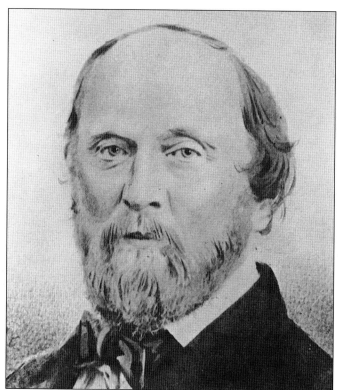

Perhaps the most famous Long Island whaling captain was Capt. Thomas Welcome Roys. Born upstate in 1916, he started his career as a farmboy-turned-greenhand on Sag Harbor's *Hudson*, rising to master in eight years. Roys was hired to command the Cold Spring Harbor ship the *Sheffield*, and he returned with oil and bone worth over $100,000, much to the thrill of the owners. (Courtesy Smithsonian National Air and Space Museum.)

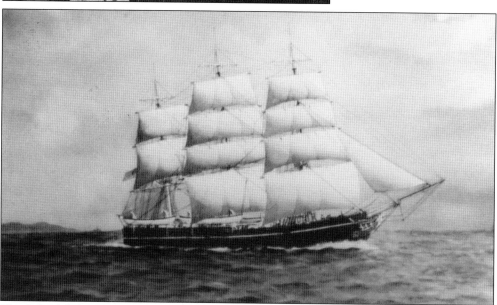

The *Splendid* championed the rise of the clippers—racing from Canton to New York in 102 days—until she herself was replaced by faster ships. In 1848, Roys captained the vessel for Cold Spring Harbor and was the first American to sail through the Bering Strait, bravely leading his terrified and near-mutinous crew through dangerous waters. When the fog lifted, he discovered a wealth of oil in the previously unknown bowhead whale (11 whales filled the ship with 1,600 barrels of oil), which revived the industry for the next 50 years.

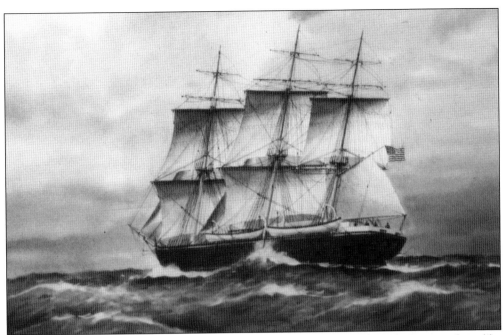

Roys next captained the *Sheffield*, a vessel all about size and speed. When she was purchased by Cold Spring, she was the largest whaling ship on Long Island and the third largest in the country at 579 tons and 133 feet long. She held records in her own right, crossing the Atlantic Ocean in 16 days. In 1849, she brought back one of the largest cargoes in the small port's history.

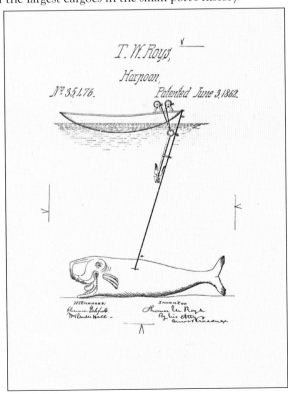

Aside from his role as captain, Roys was a scientist, explorer, and inventor. Pictured is one of Roys's early inventions, a winch-operated "whale compensator," which tried to combat the problem of sunken dead whales, such as humpbacks and blues. (Within two decades, whalers solved the problem by injecting carcasses with compressed air.) Roys also developed steam-powered factory ships, established a whaling station in Iceland, and authored a manuscript about whale species. (Courtesy US Patent Office.)

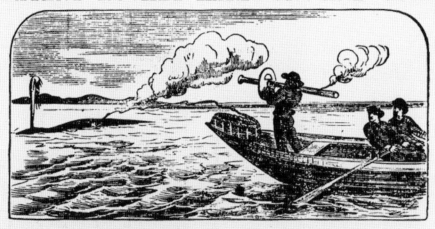

# PATENT ROCKET HARPOONS AND GUNS.

**FASTEN TO AND KILL INSTANTLY WHALES OF EVERY SPECIES.**

## WITH PROPER LINES AND BOATS,

SUCH AS WERE USED BY THE OFFICERS OF BARK REINDEER IN 1864,

**ALL WHALES ARE SAVED.**

N. B.—Two Months' notice required to fill an Order for the Season of 1865.

——FOR SALE BY——

**G. A. LILLIENDAHL,-  -  -  -  -  -  -  -  - NEW YORK**

Roys's most famous invention was a rocket-powered shell harpoon, which revolutionized whaling and had many imitators. With a range of up to 100 feet, the weapon fired a barbed harpoon that exploded after being fired. This somewhat inaccurate advertisement appeared in the mid-1860s in New Bedford's trade paper *Whalemen's Shipping List*. The device allowed whalers to pursue larger and faster whales, and while the design was ultimately unsuccessful, Roys opened the door to modern whaling. (Courtesy University of Virginia Press, Smithsonian Institution.)

This portrait of Roys was taken in Edinburgh, Scotland, in the mid-1860s. He is missing his left hand, lost in an accident while experimenting with a harpoon gun in 1856. He worked with G.A. Lilliendahl, who owned a fireworks factory, on many experiments. At the end of Roys's life, he was poor and alone; his second wife eloped with a former shipmate, he was financially destitute, and he died of an illness in Mexico in 1877. (Courtesy Smithsonian National Air and Space Museum.)

This 1894 illustration depicts Shelter Island's Capt. Benjamin C. Cartwright (1815–1896), captain of the Sag Harbor bark *Superior*. Married to Hannah Tuthill, he found business in processing menhaden after he retired from whaling. He owned the Peconic Oil Company on Ram Island, which later moved to the Promised Land near Montauk and was closed along with other factories by the board of health. (Courtesy Shelter Island Historical Society.)

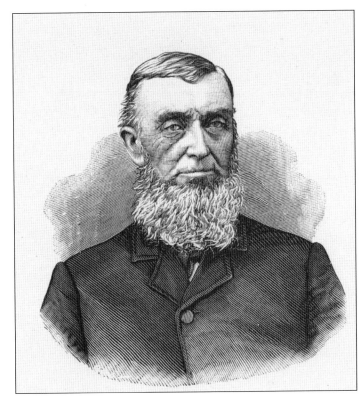

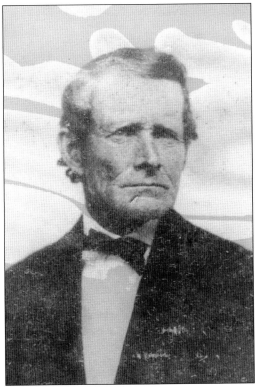

Capt. Doyle Sweeny (1815–1887) commanded the New Suffolk *Noble*, which headed to the South Seas between 1843 and 1887. Sweeny was a shareholder in the *Sabina*, which headed to San Francisco during the Gold Rush. (Courtesy Southampton Historical Museum.)

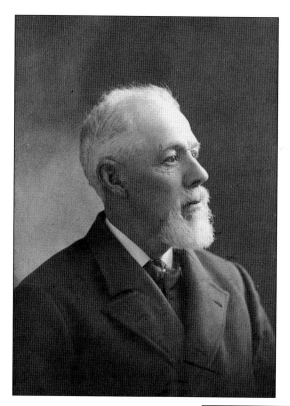

Capt. Charles Marcus Griffing (1838–1917), who fought for the Union with the 5th Rhode Island Infantry, was from Shelter Island. He married Abigail Terry Cartwright and had three children, one of whom was Capt. Roy Griffing, who perished in the 1938 New England hurricane. This photograph was taken around 1910. (Courtesy Shelter Island Historical Society.)

Shelter Island's Capt. Jacob Havens was the last of the Sag Harbor whaling masters. He escaped death several times, once caught in a sounding whale line before he could cut himself free with his sheath knife. His brig the *Myra* narrowly escaped destruction by the rebel cruiser *Alabama*. Amazingly, he escaped with a fractured skull from the jaws of a whale that crushed his whaleboat off the coast of Brazil. He recovered after a trepanning operation at a Rio de Janeiro hospital and passed away in 1904. (Courtesy Collection of Sag Harbor Whaling & Historical Museum.)

# Five

# THE AFTERMATH

## THE ISLAND'S WHALING LEGACY

Many people think whaling declined at the turn of the 20th century. While this is true for the United States and certainly Long Island, it is not true for the world. In reality, the industry just shifted, as the efficiency of the Norwegian harpoon gun opened a new and far more disastrous era of whaling. What did decline was Yankee whaling and handheld harpooning of whales on American sail-powered vessels. There were several reasons why this happened, and the biggest reason was an economic one. It was simply easier to make money elsewhere in the country.

Interestingly, the Industrial Revolution—made possible by the lubrication of whale oil—led to more economic opportunities with better wages on land, so it was soon difficult to gather a seaworthy crew together for a dangerous, laborious, and risky business. The decline of whale populations—although modern whaling had no trouble finding whales—coincided with the rise of petroleum. As women's fashion abandoned the corset, the demand for baleen dropped. The Gold Rush also launched a national shift away from whaling, with Long Island whaling captains organizing trips to seek their own fortunes. Some made it back, but some stayed in California, and many whaling ships were sold or abandoned in San Francisco. The Civil War, too, grounded the whaling industry. Some aging whaleships were deliberately sunk to blockade confederate harbors in the south, while others were chased by confederate raiders in the Arctic Ocean. Many of those who escaped raiders fell to Arctic disasters in 1871 and 1876.

When Sag Harbor's whaling industry reached its peak around 1845, a disastrous fire struck the village. The village tried to rebuild, but many of her whalers departed for California's Gold Rush in 1849. While there was a brief shipbuilding boom in the 1850s, with over $2 million in values arriving, the last whaleship the village sent out was the *Myra* in 1871. Once a particularly strong, seaworthy ship, she was condemned in Barbados in 1874 and burned for her metal; her hull was deemed unsafe to attempt to round Cape Horn. The *Myra*'s several Long Island crewmembers found their way home half a year later, unpaid. The whaling era was over.

Greenport's whaling industry dissolved in 1859 and shifted into a shipping and fishing (and later, oystering) center. Its harbor was filled with fishing boats searching for menhaden, cargo vessels, and personal boats. Cold Spring Harbor closed its whaling company in 1862, and shortly thereafter, the village shifted from a whaling port into a summer destination.

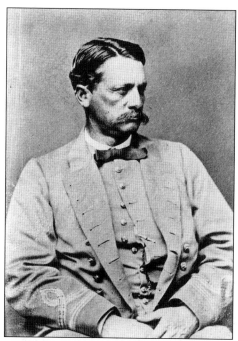

Confederate raiders regularly targeted and burned whalers. One vessel in particular that instilled fear in whalers was the *Shenandoah*, captained by James Wadell (pictured). The only Confederate ship to circumnavigate the globe, she regularly prowled Pacific and Arctic waters in search of Yankee whaleships. Whaleships were destroyed, but the crews were not hurt.

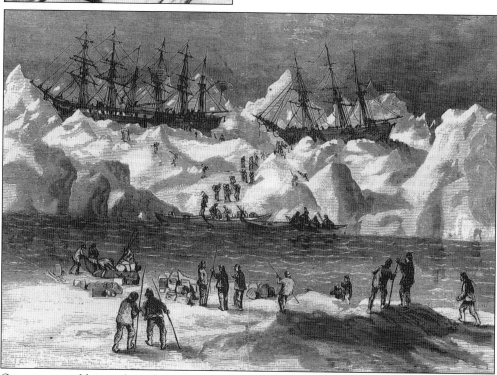

One economic blow to the industry was the Great Arctic Disaster of 1871, where an early winter trapped 33 vessels in ice. Amazingly, there were no casualties among the 1,200 crewmembers. Sketched by Capt. W. Kelly of New Bedford are the barks *George*, *Gay Head*, and *Concordia* (the latter a Sag Harbor vessel) being abandoned in the ice off Point Belcher on September 14, 1871. The vessels either sank, burned, or were stripped for wood by the Inupiat.

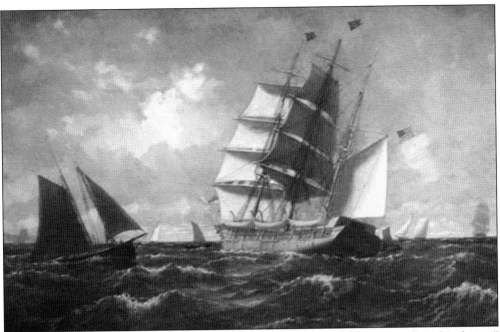

Built in 1826 in Charlestown, Massachusetts, and considered the "ultimate in whaleship design," the bark *Concordia* was one of the Sag Harbor vessels caught in the Great Arctic Disaster of 1871. Here, she is shown under full sail departing from New Bedford on her maiden whaling voyage. (Courtesy New Bedford Whaling Museum.)

John Horton, "Uncle John," was the last Montauk on a whaling vessel that sailed around Cape Horn. This is a rare photograph of the whaler and his wife in front of their home around the turn of the 20th century. Many a youth spent evenings sitting around the fire listening to his exciting stories of the whale hunt. (Courtesy Long Island Collection, East Hampton Public Library.)

With the boom of the whaling era came businesses and trades centered on supplying whaleship demands. Likewise, with the decline of whaling, Sag Harbor fell into a depression, and the decline of real estate in Sag Harbor was disastrous. This photograph shows lower Main Street, around 1859. (Courtesy John Jermain Memorial Library.)

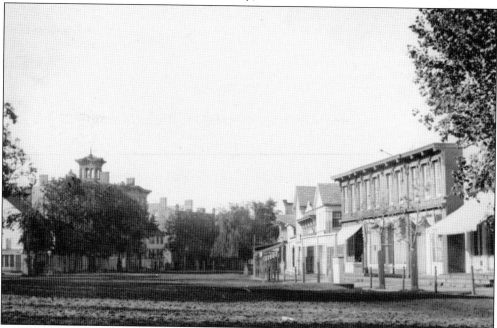

In the 1870s, Sag Harbor was described as "one deserted village—a seaport from which all life has departed." This photograph, taken by George Bradford Brainerd, shows Sag Harbor in the late 1870s. (Courtesy Brooklyn Collection, Brooklyn Museum/Brooklyn Public Library.)

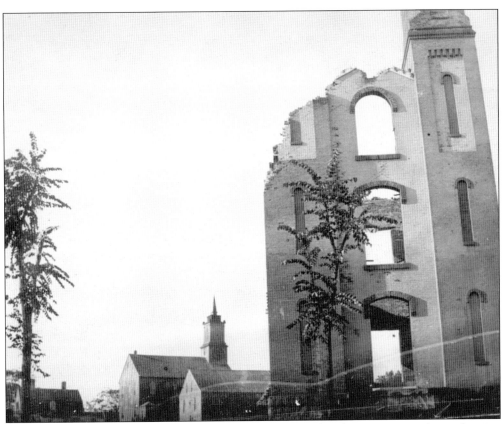

As whaling declined, Sag Harbor villagers were forced to adapt by turning to other industries, which included factories and mills. Greenport adapted by shifting to a prosperous menhaden business. Shown are the four-story ruins of the Montauk Steam Mills of Sag Harbor, a cotton-goods factory built in 1850 that later burned down. This photograph was taken between 1872 and 1887. (Courtesy Brooklyn Collection, Brooklyn Museum/Brooklyn Public Library.)

This whaleboat is reportedly from the 265-ton *Concordia*, which sailed out of Sag Harbor in 1837 to the South Atlantic. She was engaged in the whaling industry until she was frozen in ice in 1871. This particular boat was later used for a number of years in offshore whaling at Amagansett. It is now on display at Sag Harbor Whaling Museum. (Courtesy New York Public Library.)

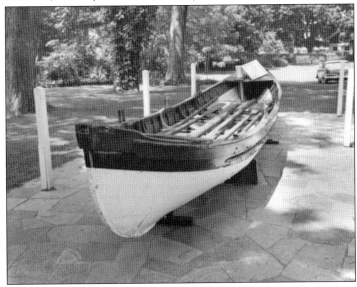

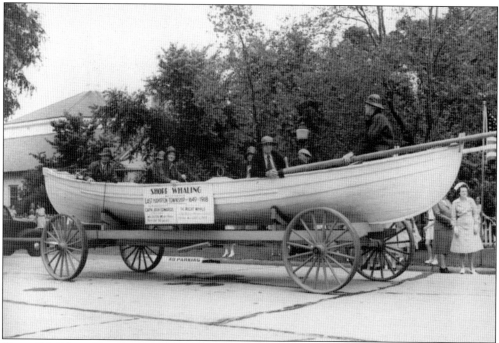

Capt. E.J. Edwards and whaling crew—from Amagansett, Wainscott, Sag Harbor, and East Harbor—join the Ladies Village Improvement Society for the 50th anniversary parade in 1945. (Courtesy Long Island Collection, East Hampton Public Library.)

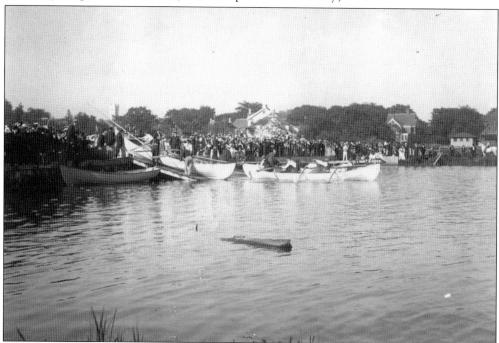

Towns continued to show local pride in their whaling past through various reenactments and parades, as pictured at Lake Agawam in Southampton in 1915. (Courtesy Collection of the Southampton Historical Museum.)

Whale jaw bones form this arch over the gateway of the former residence of Felix Dominy at the southerly corner of Pantigo Road and Egypt Lane in East Hampton. Other local entrances were flanked with whale jaws, including 15-foot jaws at Middle Lane Pottery in East Hampton from a whale caught off Long Island. (Courtesy Long Island Collection, East Hampton Public Library.)

An East Hampton crowd waits in front of the Edwards Theater to see the 1920s silent whaling film *Down to the Sea in Ships*, to which all the senior whalers in East Hampton were given free passes. When this experienced crowd saw the Hollywood amateurs throwing harpoons, the silence was broken by their caustic comments. (Courtesy Long Island Collection, East Hampton Public Library.)

Pet food and margarine were modern products from whales. In the early 1900s, whale oil was successfully hydrogenated, losing its unpleasant smell and fishy taste. In the 1920s and 1930s, 30 to 50 percent of European margarine was made with whale oil. Below, a whale meat recipe is visible in reverse on the transparent plastic package.

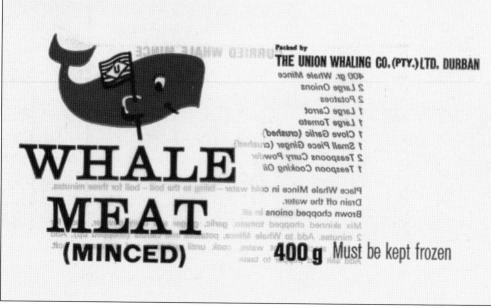

Ambergris is a waxlike substance literally worth its weight in gold. Produced in a sperm whale's intestines, ambergris (Latin for "gray amber") was used as a highly valued fixative for perfumes. Today, a synthetic version is used. It is believed that ambergris eases the passage of sharp squid beaks through the whale's four stomachs and intestines.

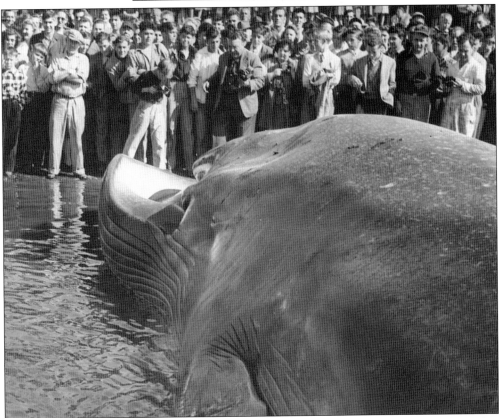

A 62-foot fin whale was stranded in Huntington in 1946; the happening was so sensational that school let out. The whale was towed to sea in an attempt to save it, but it unfortunately died. This event marked a changing of the tides in regards to people's evolving feelings about whales. The 1972 Marine Mammal Protection Act now protects whales in the United States.

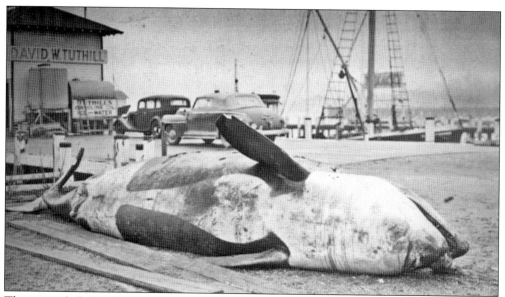

This orca whale was beached in Orient Point, Long Island, in January 1944 and is seen on the Claudio dock. It was towed to Greenport, where Charles Davenport, one of the founders of the Whaling Museum in Cold Spring Harbor, kept the skull for exhibition. Instead of using a slower but easier method of maceration in a pond, he boiled it in a cauldron in an open shed in the bitter winter. He caught a cold, pneumonia set in, and he died that February. The skull remains on display today. (Courtesy Antonia Booth.)

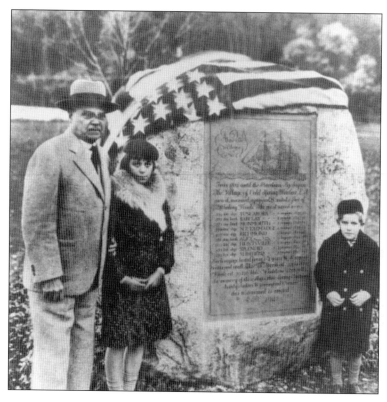

After the whaling industry died in Cold Spring Harbor, the village became a popular summer resort. In 1932, residents commissioned a plaque in commemoration of the village's history, as seen here. The Whaling Museum Society was formed in 1936, a century after the whaling company there was founded.

When Robert Cushman Murphy obtained one of the whaleboats from the *Daisy* for a museum display, he offered it to Cold Spring Harbor. After several years of convincing, the community came together to found The Whaling Museum on Main Street, opening its front doors in August 1942. The museum has seen several additions since then, with offices in Capt. James Wright's 1894 home, located adjacent to the museum. (Courtesy Peter Schwind.)

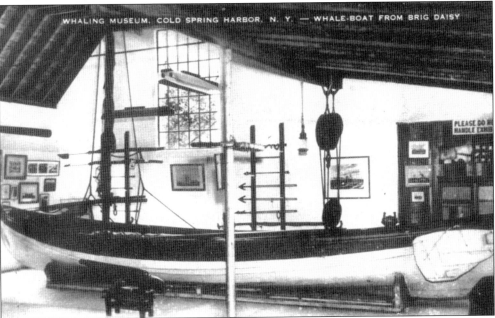

WHALING MUSEUM. COLD SPRING HARBOR. N. Y. — WHALE-BOAT FROM BRIG DAISY

The whaleboat on display in Cold Spring Harbor is the only whaleboat with all its original gear on display in New York state. Today, the museum uses the vessel as an educational tool, applying local whaling history by creatively exploring diverse themes in art, science, history, and culture. (Courtesy Peter Schwind.)

# DISCOVER THOUSANDS OF LOCAL HISTORY BOOKS FEATURING MILLIONS OF VINTAGE IMAGES

Arcadia Publishing, the leading local history publisher in the United States, is committed to making history accessible and meaningful through publishing books that celebrate and preserve the heritage of America's people and places.

Find more books like this at
**www.arcadiapublishing.com**

Search for your hometown history, your old stomping grounds, and even your favorite sports team.

Consistent with our mission to preserve history on a local level, this book was printed in South Carolina on American-made paper and manufactured entirely in the United States. Products carrying the accredited Forest Stewardship Council (FSC) label are printed on 100 percent FSC-certified paper.

**MADE IN THE**